SECRET
EXETER

Tim Isaac & Chris Hallam

AMBERLEY

Acknowledgements

General thanks to Martyn Beckett, Jim Davis, Ed Oldfield, JoJo Spinks, Simon Stabler and Rachael Holden. Also, Exeter City Council, Devon County Council and Exeter Cathedral. Finally, thanks to Nick Grant and Alan Murphy at Amberley.

Books and websites:
Gollancz, Israel (translator), *The Exeter Book: An Anthology of Anglo-Saxon Poetry Presented to Exeter Cathedral by Loefric, First Bishop of Exeter (1050–1071), and Still in Possession of the Dean and Chapter*
Harvey, Hazel, *The Story of Exeter*
Hope, Vyvyan, and Lloyd, John, *Exeter Cathedral: A Short History and Description*
Hoskins, W. G., *Devon*
Hoskins, W. G., *Two Thousand Years in Exeter*
Orme, Nicholas, *The Cathedral Cat: Stories from Exeter Cathedral*
Thomas, Peter D., *Exeter Burning: The Exeter Blitz Illustrated*
The works of Dr Todd Gray
exetermemories.co.uk

First published 2018

Amberley Publishing
The Hill, Stroud
Gloucestershire, GL5 4EP

www.amberley-books.com

Copyright © Tim Isaac and Chris Hallam 2018

The right of Tim Isaac and Chris Hallam to be identified as the Authors of this work has been asserted in accordance with the Copyrights, Designs and Patents Act 1988.

ISBN 978 1 4456 7931 0 (print)
ISBN 978 1 4456 7932 7 (ebook)

British Library Cataloguing in Publication Data.
A catalogue record for this book is available from the British Library.

Origination by Amberley Publishing.
Printed in Great Britain.

Contents

Introduction

Welcome to Exeter. Regardless of whether you are a resident, a visitor, a student or just someone who is vaguely interested in this book, you have undoubtedly made an excellent choice.

First and foremost, Exeter is a fine place to live. Like Goldilocks' third bowl of porridge, it is neither too hot nor too cold, but just right (although it is admittedly sometimes too wet). It is the perfect size: it is not too big and not too small. Exeter is just big enough to be practical but not so gigantic as to be overwhelming. It is neither Brobdingnag nor Lilliput. Assuming you are reasonably fit, it is easy to walk into the countryside from virtually anywhere in the city.

Exeter has everything a modern city needs: schools, shops, a university, a cathedral and a climbing wall. Want to go to the cinema? There are three to choose from. Want to go for a walk? Why not visit the historic Quayside? And if you have, for some reason, really had enough, you can leave. As the comedian Hugh Dennis has pointed out, Exeter 'has a surprisingly high number of railway stations relative to the size of the population'.

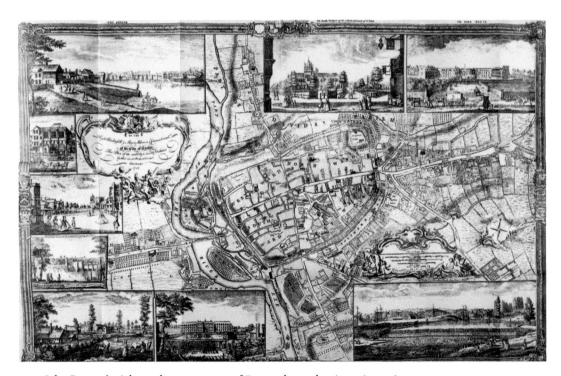

John Rocque's eighteenth-century map of Exeter shows the city as it was in 1744.

However, this is not a tourist brochure. The aim of *Secret Exeter* is to shed light on the hitherto less renowned aspects of Exeter's history. This is both easier and harder than it sounds. On the one hand, Exeter's history is very apparent. It's hard to walk very far at all without seeing some reminder of it: a cannon on the Quayside, a statue of a soldier on a horse, or a section of the city wall. On the other hand, these are all arguably so well known and obvious as to not really qualify as 'secret' – surely everyone knows about them? While many people pass them by, few know their real history.

Another factor is the surprisingly large number of obscure and sometimes incredible facts in the city's history. Ultimately, we've decided not to try and second guess what people know, as it is impossible for us to know what you, the reader, are aware of. One person's revelation is another's hoary cliché. We hope everyone will find something in here that they didn't know before, whether it's murderous mayors or evidence of bomb damage that residents of the city may have walked past hundreds of times without knowing that's what it was.

Indeed, our particular interest isn't only in telling the history and stories of Exeter past, but how hints and evidence of the city's history still exist around every corner in buildings, place names and in the ground itself – as long as you know what you're looking for. Perhaps the best example is that while most Exonians (which is the collective noun for people from Exeter) know there's an area of the city called Countess Wear, fewer realise it's not just a name, as there really was a countess who had a weir built across the River Exe. Even fewer know that her actions set off a chain of events between the townsfolk and the aristocracy that shaped the city's history over the course of 400 years. More on that later.

As the city has existed for over 2,000 years, it certainly has a varied and colourful past, so it's best to begin at the very start.

Chris Hallam and Tim Isaac,
September 2018

1. Old Exeter

Exeter has been known by many different names in its time: Caerwysc, Isca Dumnoniorum, Exancaester and less formally as Monktown, the 'Metropolis of the West' or the 'London of the West'. The name Exeter itself comes from the river that runs through it, the Exe, which rises on Exmoor in Somerset and flows across Devon, through Exeter before entering the English Channel at Exmouth. The word 'Exe' itself comes from the Old English word for 'river' or 'water', so Exeter essentially just means 'town/settlement on the river'.

Romans

Although the hill the oldest parts of Exeter stands on has been inhabited since at least 200 BC, it was only after the arrival of the Romans that it became a major urban centre. The Romans came to Exeter in force in the middle of the first century AD. While they quickly subdued many of the tribes in Britain, the Dumnonii (also known as the Dumnones) tribe of south-west Britain proved a trickier proposition. Disputed tradition says that the great Roman general Vespasian (later to become emperor) came to Exeter in person in the mid-first century and besieged the fortified town for eight days. He failed to capture the settlement – which was then known as Caerwysc or Caer-pen-huel-goit – only making peace and entering when a British queen mediated between the two sides.

Despite this, the Romans found the south-west of Britain difficult to govern. This was partly due to the fact the Dumnonii were probably a loose confederation of tribes, many of whom never accepted Roman rule, particularly in Cornwall (it used to be believed that Exeter marked the Romans' western frontier in Britain, but more recently evidence of Roman activity has been discovered all the way down into Cornwall). This proved problematic for the Romans, as it was the tin under the ground of Devon and Cornwall that made controlling this part of Britain so attractive to them.

Due to this need for a constant military presence to keep the locals in line, very soon after the invasion, Exeter became the site of one of the first permanent Roman forts in Britain, which functioned as the main base for the Second Legion for the early part of the Roman occupation. The town was named Isca Dumnoniorum, meaning 'river/waters of the Dumnonii' (or according to some sources, 'capital of the Dumnonii').

The Romans showed their might and technical prowess very soon after taking control of Exeter, resulting in one of the city's greatest secrets. The earliest cut and mortared stone-built building in Britain lies under the west front of Exeter Cathedral. Excavated in the 1970s, much of the bathhouse, which dates from around AD 55, still exists a few feet underneath the soil. The impressive remains have since been covered over again to protect them, although the cathedral still hopes to find a way to safely uncover and display them to the public. The discovery of the bathhouse, as well as other Roman finds

Above: The west front of the cathedral gives little hint that the remains of a Roman legionary bathhouse still lie under the surface. (It was also the site of Exeter's very first cathedral.)

Right: The corner of Gandy Street and Upper Paul Street is believed by some to mark the corner of the original Roman fort that was built in Exeter in the mid-first century AD.

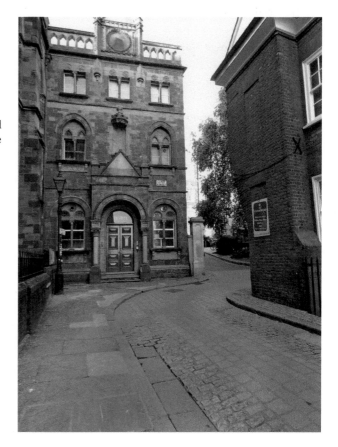

made during the construction of the nearby Guildhall shopping centre (most notably evidence of wooden barrack blocks), were the first direct evidence that Exeter was the Roman military centre that tradition said it was.

Although some of Exeter's other Roman secrets also remain under the ground – such as the second-century basilica (town hall) that was also discovered under the Cathedral Green – others are hiding in plain sight. For example, it's believed by many that the intersection of Gandy Street and Upper Paul Street still marks where one corner of the Roman fort stood.

DID YOU KNOW?
Just next to the Guildhall entrance to Marks & Spencer is a small sectioned-off triangular area containing some cobbles. This is a small section of the original Roman road surface discovered under the site when it was excavated in the 1970s (although moved a few metres from where it was originally uncovered). Other Roman finds from the Marks & Spencer and Guildhall Shopping Centre site are now in the Royal Albert Memorial Museum including some fine mosaics.

Just next to the Guildhall entrance of Marks & Spencer is a preserved section of the original Roman road surface that was excavated in the 1970s.

Then there are the city walls. Originally an earthen bank around the city believed to have been constructed around AD 120 (this bank can still be seen in Rougemont Gardens), the Romans further fortified the city with stone walls around AD 200. Although most of the Roman work has since been removed or rebuilt, the current city walls pretty much run along the same lines as when the Romans established them 1,900 years ago.

Some of the original Roman walls remain though, such as along the aptly (but recently) named Roman Walk. However, it is in Northernhay Gardens where the best remains of Exeter's Roman walls still exist. The Roman work can be seen in the foundations of the impressive fortification that runs around the edge of the hill that Exeter Castle sits upon. This stretch of wall is considered by some to be among the most important in the country, as it one of only a few in the UK to contain evidence of work from nearly every major period of English history over a 1,500-year span, including input from the Romans, British, Anglo-Saxons and on through the medieval period.

Yet more evidence of how long the Romans' influence has remained in Exeter can be seen in the fact it's not an accident that Magdalen Road, just outside the city walls, is so straight. It was cut by the Romans as the main approach road to the city, leading up to where the South Gate (also known as the Great Gate), used to stand. This remained the main ceremonial entrance for well over a millennium. The adjacent, and equally straight, Topsham Road was also cut by the Romans to ensure easy access to the fishing and port at Topsham.

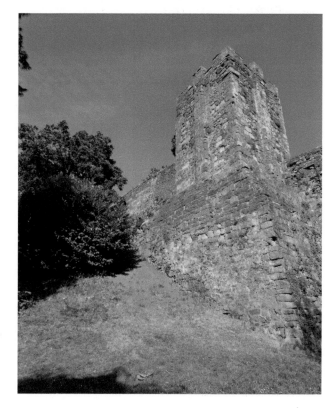

The city wall in Northernhay Gardens is considered particularly important as it features work from Roman, British, Anglo-Saxon and medieval builders. While the pictured tower is named after the Anglo-Saxon king Athelstan, who refortified the city in the tenth century, it is believed to have been built in the Norman era.

DID YOU KNOW?
According to the Roman historian Tacitus, during Boudicca's uprising in AD 60 the prefect of the Second Legion in Exeter, Poenius Postumus, was ordered to bring troops to help put down the rebellion. However, he ignored the call. When the Romans were victorious at the Battle of Watling Street, Poenius killed himself by falling on his sword. While it was said he did this because he'd denied his men their share of glory in victory, it's more likely he did it to retain some semblance of honour, as he knew he'd be severely punished and probably executed for the grave mistake he'd made by ignoring the orders.

Anglo-Saxons

After the Romans left Britain in the fifth century – and indeed for some time before – it appears Exeter was struggling. The best evidence of this is the lack of any evidence at all. For almost 300 years there's very little to show that Exeter still existed – few coins, mentions in histories or anything else. It must have persevered though, although it's likely the population shrank markedly and with the end of trading links to the Roman Empire, the local people experienced significant poverty.

Things changed in AD 658 when the Anglo-Saxons arrived. They took over Exeter and essentially split the city into two, with the richer Saxons occupying most of the settlement, and the indigenous population limited to what became known as the British quarter. This part of the town is around what is now Bartholomew Street (which was known as Britayne right up to the Middle Ages). The rabbit-like warren of streets and alleys between Fore Street and Bartholomew Street is believed by many to be a hangover of this period.

Much of the current street plan within the walls of Exeter was laid out when the city was 'refounded' by King Alfred the Great in the ninth Century. Although the basic line of some Roman roads remained – most notably much of the giant cross that cuts Exeter north–south and east–west and which led towards the city's main gates, marked by High Street, Fore Street, North Street and South Street – most of the other streets date to the Saxon period.

Relatively little direct evidence of the Saxons' time in Exeter remains. Burials have been found under the Cathedral Green and a few coins have been discovered, but much of the rest is only known through second-hand histories. Some evidence does still exist in place names, such as Wonford and Duryard. These were both royal estates during Saxon times and may have existed even earlier. The name Wonford (which probably means the 'fair stream' or 'holy stream' or possibly the 'battle stream') is now used for a small area of the city close to Heavitree and is best known for being where the main Royal Devon & Exeter Hospital is situated. In the past though, it used to be a vast estate that stretched around three sides of the city and was directly controlled by the king. Likewise, Duryard, probably meaning 'Deer Fold', is now chiefly remembered in folk memory as the area around the University of Exeter, and as the name of one of the halls of residence on the campus. However, it was once a large, rich forest used by the Anglo-Saxon kings for hunting when they visited.

All was not peaceful under the Saxons though. In the tenth century, King Athelstan decided to upset the status quo of having both British and Saxons living within the city walls by evicting the British from the town. It is not known precisely why he did this. It may have been due to ongoing tensions between the two 'tribes', but as Athelstan was interested in refortifying the city and increasing its prestige, he may just have wanted to rid the city of its most impoverished people. It could have been an early example of gentrification, as it appears not long afterwards more affluent people moved into the British quarter and swept away the rough housing that had previously existed. Although it's not known exactly what happened to the people who were thrown out of the city, it's likely they were forced to move to Cornwall.

Tradition also says it's Althestan who changed the name of the settlement to Exancaester, which over the centuries evolved into its modern name – Exeter.

Danes

While the Vikings raided and conquered parts of England over the course of 200 years, the south-west of the country was less troubled by the Danes than many other areas. Exeter didn't come through completely unscathed though, with the Vikings capturing the city in 876, before being repelled by King Alfred the following summer. This event is believed to have spurred King Athelstan to rebuild the decaying city walls and ensure Exeter was properly defended. This refortification worked when the Vikings returned in 1001, but not in 1003. In that year the Vikings laid siege to the city and it's recorded that Hugh, rent collector for King Ethelred II's wife, Emma (who owned Exeter), opened the gates to allow them in. No one knows why he did it, but the result was that much of the city was burnt and plundered including the abbey that existed at the time. Luckily, though, the Vikings didn't stay.

Virtually no evidence of Vikings in Exeter remain, so why is an area near Exeter Prison known as Danes Castle? While some still say it's because the small banks and fortifications found there were created when the Vikings laid siege to Exeter, historians believe this is almost certainly a misattribution, and that they were built several hundred years later. The Danes Castle name and Viking designation didn't arrive until the eighteenth century, but has ensured an association with the Norsemen is retained in the popular memory.

Normans

We all know the story, or at least we think we do. In 1066, the Saxon King Edward the Confessor died, and may have promised the English throne to William, Duke of Normandy. When the Saxon Harold claimed the English crown instead, William came over and defeated him at the Battle of Hastings. The invasion by William the Conqueror as later depicted on the famous Bayeux Tapestry, ushered in centuries of Norman rule.

What is less well known is Exeter's defiant role in resisting the invasion. Long after the rest of the land had been defeated, Exeter held out against the forces of William. Indeed, the Norman king came perilously close to never conquering Exeter at all.

After William was victorious at Hastings, Exeter refused to swear an oath to him, or pay him the increased tribute he thought he was due. Indeed, it was vociferous enough in its opposition that Harold's mother, Gytha, took refuge in the city (although some sources suggest she may have already been living here and helped stoke the anti-William

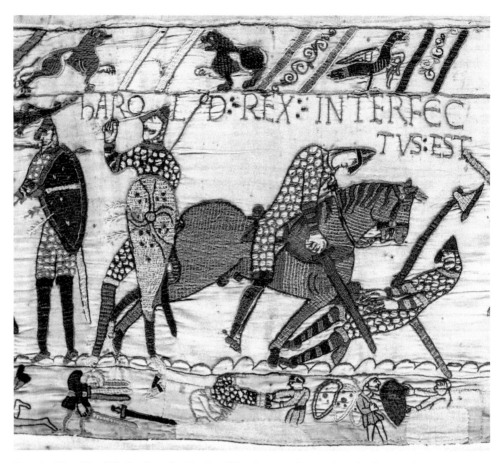

Despite King Harold's death at the Battle of Hastings, as depicted in the Bayeux Tapestry, Exeter refused to accept William as its new king.

sentiment). William wasn't about to accept this, and so he and his army returned from Normandy and marched on Exeter.

The new king quickly tried to show the citizens of Exeter that he was not a man to play with, ignoring the city's attempts to bargain and publicly blinding one of the hostages that had been given to him as a sign of good faith. William laid siege to Exeter for over two weeks before the city's leaders negotiated its surrender. This involved William promising not to harm the city or increase its tribute. During all this time it's thought that William had no idea he was so close to Gytha, who was smuggled out of the city just before the new king entered.

Due to all this trouble, the Normans decided they needed to stamp their authority on Exeter and so almost immediately they tore down the houses that stood on the hill at the northernmost parts of the walled city, and began construction of a new castle. Known as Rougemont (Red Hill, because of the colour of the volcanic soil) Castle, it was the fortified centre of royal power in the city for several hundred years. However, little of the original or indeed later iterations of the castle buildings remain, as most

of the Norman and medieval structures were removed after the Civil War, and the construction of a Georgian court building destroyed even more. As a result, it is largely just the castle walls that remain.

Those walls include one of Exeter greatest but least-regarded treasures. At the top of Castle Street, just to the left of the current entrance to the castle precinct, is the original Norman gatehouse built in 1068. It is an incredibly rare survival and considered to be one of the best pieces of early Norman architecture in the UK. It is certainly the earliest Norman castle building still surviving, predating the more famous White Tower at the Tower of London by about a decade.

However, perhaps its real secret is that it only survived intact because of how problematic it was. Shortly after the construction of the castle, it's believed the Normans realised that the approach they'd built through the gatehouse was causing issues for access due to its steepness. Not too long after it was built the original gatehouse was sealed, and a new entrance and approach was created next to it. If it had continued in use, it is almost certain it would have been destroyed or at least severely altered as tastes and uses of the castle compound changed. Instead, it's been able to quietly survive to the present day, giving a rare insight into the very earliest days of Norman rule.

Incidentally, it was William taking over that gives us our first information about how many people lived in the city, with the walled area said to contain 460 houses and a population of 2,500. This may not sound very many, but at the time this would have made it a major population centre. It's also worth noting Exeter may have had far more inhabitants during Roman times as the overall population of England at that point was significantly larger, but no records exist of how many people Isca supported.

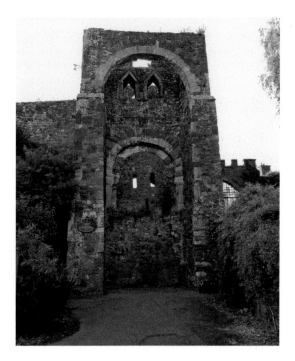

The gatehouse of Exeter Castle is the oldest Norman castle building in Britain.

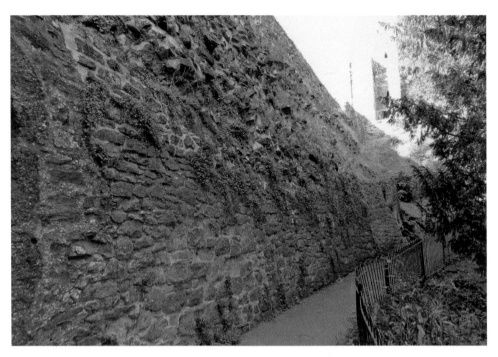

In Rougemont Gardens it's possible to see everything from the original earthen bank that predates the city wall to the enormous fortifications, banks and ditches built to protect the Norman castle.

While nearly all of the Norman and medieval Rougemont Castle was destroyed following the Civil War, the still standing walls show what an impressive fortification it once was.

2. Christian Exeter

For many people, the word 'Exeter' immediately conjures images of its beautiful cathedral. However, it's not just a building. It and the many other religious establishments in Exeter have shaped the city profoundly. The evidence of that is in just how many churches Exeter contains. At one point there were almost thirty churches just within the city walls. The Cathedral Green alone had three, and that's not including the great church itself. However, one of Exeter's secrets is that originally it wasn't supposed to be a cathedral city at all.

A Cathedral Foundation

When the church in Rome created a new diocese for Devon during the Saxon period, they chose to centre it in Crediton rather than Exeter. Although Exeter had a minster

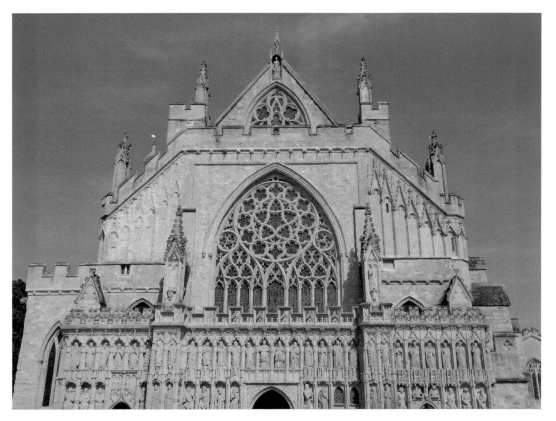

The image of the fourteenth-century west front of Exeter Cathedral has become synonymous with the city itself.

or monastery from at least the seventh century (situated just to the west of the current cathedral), Crediton had the benefit of being a site of veneration for an important saint.

St Boniface is believed to have been born in Crediton in AD 675. He was educated in Exeter and as an adult became a key figure in the Anglo-Saxons' attempts to spread and properly organise the church in the parts of the Frankish Empire, which would later become Germany and its environs. He was eventually martyred while attempting to convert the Frisians. Boniface quickly became a revered figure across Europe, particularly in Germania, where he became the patron saint. He was known by some as the 'Apostle of the Germans'.

Due to its links to Boniface, when a new diocese was created in Devon in 909, Crediton was chosen as its centre, and the new bishop, Edwulf, established a cathedral there in 910. This decision could have shifted the focus of Devon from Exeter to Crediton, just as some of Britain's other great cities emerged from the decision to site a cathedral there. However, in 1050, the 10th Bishop of Crediton, Leofric, petitioned the Pope to move the see from Crediton to Exeter, and also to bring the separate diocese of Devon and Cornwall together under his control. The move wasn't just because Exeter was a larger population centre, but also because it was better protected from the lawlessness of other parts of the county.

The bishop's seat was moved into Exeter's Anglo-Saxon minster and it became a cathedral (a 'cathedral' is literally where a bishop's official seat/throne resides. This seat is also known as a Cathedra, from the Latin for 'chair'). The new cathedral is likely to have been a wooden building, of which little direct evidence remains. It was also probably quite small, as there are suggestions that Leofric often had to hold services/ceremonies outside.

The foundation charter from Edward the Confessor detailing the formation of the new diocese and the enthronement of the new bishop – a ceremony attended by Edward himself – is still held in the Cathedral Library. It is a unique document, as no other similar record from so long ago exists. Interestingly, it says that another one of the people present at the enthronement was Harold, who would later briefly become king before being killed fighting William the Conqueror's army at the Battle of Hastings – something which as we've already seen caused Exeter a lot of problems.

As well as making it a cathedral city, Leofric made another incredibly important contribution to Exeter, which was his library. He was a book lover at a time when books were extremely rare, expensive and precious. Leofric was already a man of power and money before he became a bishop, thanks to his friendship with Edward the Confessor. This allowed him to collect a variety of manuscripts, which he left to the cathedral and which formed the basis for its library. Sadly, in the years since, nearly all of Leofric's manuscripts have been lost or ended up in other collections. The one major exception is the Exeter Book, which we'll find out more about later in this chapter.

Building in Stone
After Leofric's death in 1072, the Normans helped cement their power in the city by ensuring (as they did in most cities) that the next bishop came from their ranks. However, it wasn't until William's nephew, William Warelwast, took over as bishop in 1107 that the

idea of Exeter having a grand stone cathedral took shape. This new building is believed to have been started in 1112, just adjacent to the small wooden cathedral. It is evidence of what a monumental project the new Norman cathedral was that it took twenty-one years before it was in a state that it could be used, with the bishop's seat moved from the old cathedral in June 1133. That's not to say it was finished at the point – far from it – as construction continued until the end of the twelfth century.

Despite the tremendous effort and decades that had gone into building it, only sixty years after it was completed, Bishop Walter Bronescombe decided the building was already outdated. He had visited Salisbury and been impressed by the new style it was built in (a style later known as Decorated Gothic). Its mix of ornate features and clever engineering meant that monumental buildings could be made much lighter and airier. For example, Norman buildings often had to have small windows, as the walls needed to be solid and massive just to hold up the roof. However, putting buttresses on the outside of the building transferred a lot of the weight outwards, allowing for thinner walls, smaller columns and much larger windows.

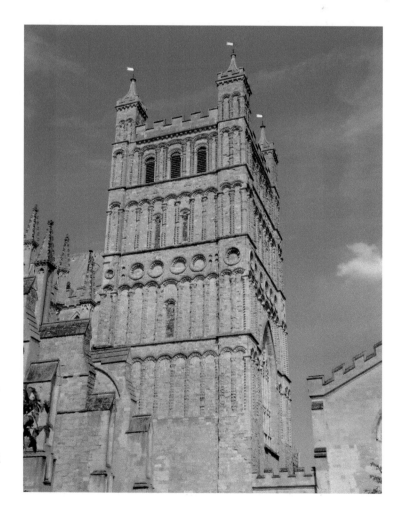

The towers survive from the twelfth-century Norman cathedral, while most of the rest of the building is from a Decorated Gothic rebuild in the thirteenth and fourteenth centuries.

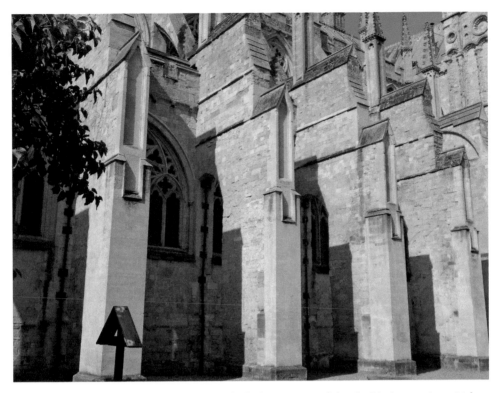

Flying buttresses on the outside of the cathedral were one of the Gothic innovations Bishop Bronescombe brought back from Salisbury. They allowed the new building to being far lighter and airier than the previous incarnation by transferring the weight of the building outwards.

Bronescombe brought these Gothic innovations back to Exeter and set about rebuilding the cathedral in the Decorated style. It took so long to complete that it wasn't finished until the tenure of Bishop Grandisson, five bishops later, in the mid-fourteenth century! The result is a building that looks harmonious but which most people don't realise is from two distinct periods (with some later, comparatively minor, alterations). The two towers are from the original Norman cathedral, while most of the rest of the building is from Bishop Bronescombe's rebuilding in the thirteenth and fourteenth century.

It's not properly known why Bronescombe chose to keep the original towers, but they are unique in English cathedrals, as no other has two monumental towers as its transepts. This arrangement also means that there is no tower or spire over the central crossing of the cathedral, allowing for one of Exeter's better-known secrets. As the ceiling can run uninterrupted from one end of the cathedral to the other, Exeter has the longest continuous stretch of medieval vaulted ceiling in the world at 96 metres (315 feet).

Since the fourteenth century, the cathedral has seen some changes and rebuilding, such as the destruction of the medieval cloisters following the Civil War, but it has survived far more intact and cohesive than many other English cathedrals. That includes only suffering comparatively minor damage and destruction during the Reformation.

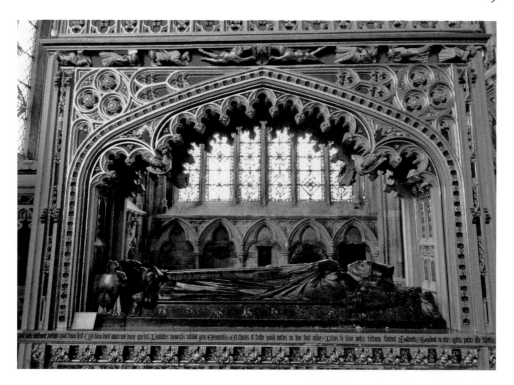

Above: In the Lady Chapel is the tomb of Bishop Walter Bronescombe, the man responsible for initiating the Decorated Gothic rebuild of the cathedral.

Right: The cathedral has the longest uninterrupted stretch of medieval vaulted ceiling in the world at almost 100 metres.

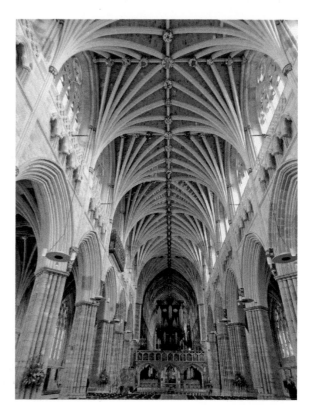

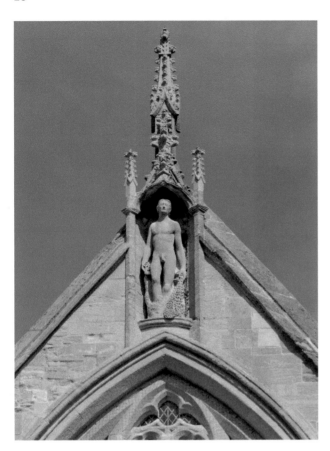

Few people notice that at the highest point of the west front of the cathedral is a medieval statue of St Peter (who the building is dedicated to), who unusually is depicted in the nude.

It also got a fairly sympathetic treatment during the Victorian period, when a zeal to 'restore' major churches in the Decorated Gothic style saw some cathedrals drastically altered, with original features ripped out and replaced by what the restorers thought ought to be there, but which fundamentally changed their character. One of the Victorian era's greatest architects, Sir George Gilbert Scott, did do some work on Exeter Cathedral, but while his efforts with numerous other religious buildings have been criticised, he only worked on Exeter for a relatively short time and his alterations weren't too ruinous. That said, it does mean that not everything in the building is as it appears. For example, while the choir stalls may look ancient and in keeping with the medieval woodwork of the bishop's throne, they were actually designed by Scott in the nineteenth century.

Cathedral Treasures

While the cathedral building itself is one of Exeter's greatest treasures – as the historian W. G. Hoskins wrote in his book *Devon*, 'Exeter may well claim to be the loveliest of all English cathedrals' – it also contains other precious secrets. Many of these are hiding in plain sight, with people either not knowing what they are or missing them among the more grandiose tombs and chapels.

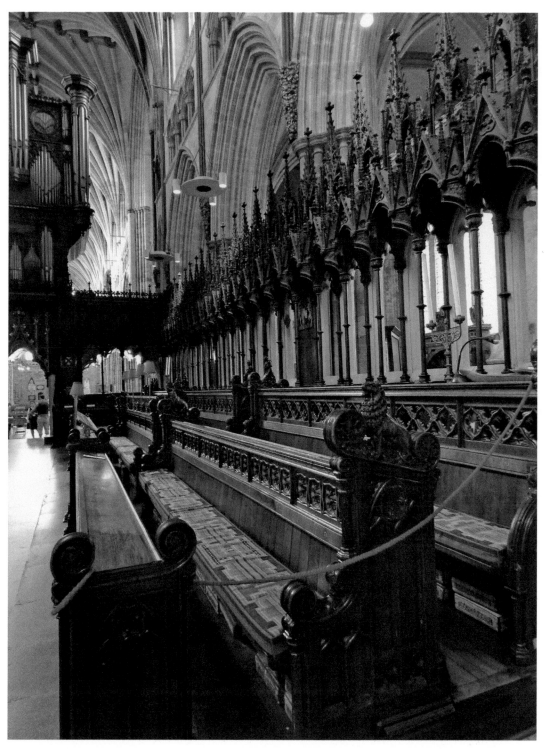

The choir stalls look medieval but were actually designed by George Gilbert Scott in the nineteenth century.

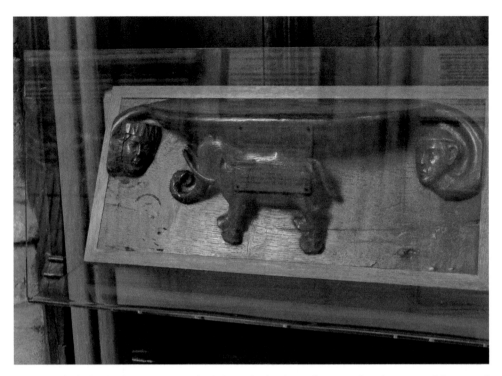

Exeter Cathedral's elephant misericord is believed to be the earliest wooden depiction of the animal in the UK.

Elephant Misericord

One of the better known of Exeter Cathedral's secrets is its very own elephant. The carving of an elephant on a thirteenth-century misericord is the earliest known wooden depiction of the animal in the UK. It's almost certain that the carver never actually saw an elephant, not least because they gave it splayed hooves. What's less known though is that the elephant is just one from the earliest complete set of misericords in the world. A misericord is a type of folding seat used in medieval churches to give support to those who had to stand for long periods, normally offered to those who were old or infirm (they were also known as 'mercy seats'). Exeter's set of thirty thirteenth-century misericords include depictions of mermaids, griffins, dragons and centaurs, so perhaps the elephant sculptor thought they too were just carving a fantastical beast.

Bishop's Throne

Another early survival is the 18-metre- (58-foot-) tall bishop's throne and canopy – the tallest in the country. Carved from Devon oak between 1312 and 1316, it is considered by many to be one of the greatest surviving examples of medieval woodwork in Europe. Remarkably, the cathedral records still contain evidence of when and where the trees used in its construction were felled. While it is now a plain wooden colour, evidence suggests that it was originally painted white and gold and was overpainted several times until it was stripped back to the original wood in the Victorian era.

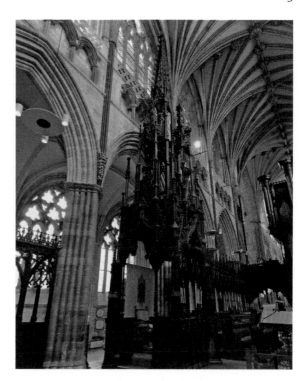

The bishop's throne and canopy is the tallest in the UK at 18 metres high.

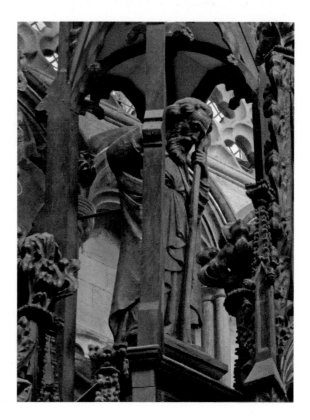

A fourteenth-century wooden statue of St Peter looks down upon the bishop from high up in the canopy of the bishop's throne.

Captain Scott's Sledging Flag

Tucked away in the south-west corner of the cathedral and completely ignored by most visitors is one of its most unexpected treasures: the flag that flew on the sledge of Sir Robert Falcon Scott during the British National Antarctic *Discovery* Expedition of 1901–04. Oddly though, Captain Scott – who infamously died alongside the rest of his party after reaching the South Pole in 1912 – didn't actually have that many links to the city. He was a Devonian though, having been born and brought up in Plymouth. To celebrate those Devonian links, in 1920 Scott's family donated the flag to Exeter Cathedral, where it has hung ever since.

Minstrel's Gallery

High up on the north side of the nave is a balcony known as the Minstrel's Gallery. It's not known what it was built for but tradition says that it was created in the fourteenth century for musicians or singers, with its height allowing the music to float out across the assembled crowds below. However, there's little direct evidence of this and the attribution may be due to the colourful depiction on the balcony of angels playing medieval instruments such as bagpipes, harp, gittern, shawm and portative organ.

Loosemore Organ

It is one of the most striking sights in all of England, the magnificent Exeter Cathedral organ sat atop the medieval screen and framed by soaring columns and the longest Gothic vaulted ceiling in the world. The organ dates from the seventeenth century and replaced

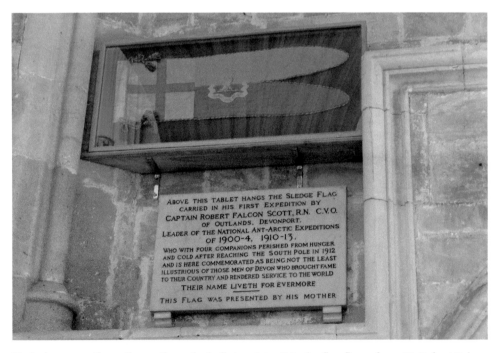

Tucked away on the wall near the cathedral's tourist exit is the flag flown from Sir Robert Falcon Scott's sledge during the British National Antarctic *Discovery* Expedition of 1901–04.

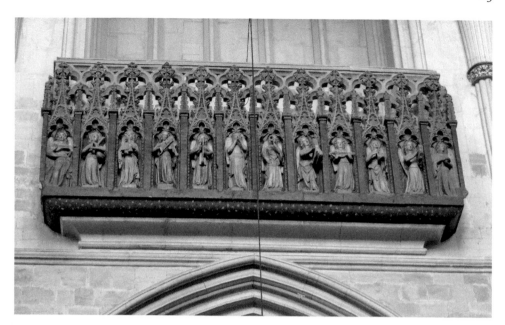

Above: High up in the nave is the Minstrel's Gallery, decorated with colourful images of angels playing medieval musical instruments.

Right: Unusually the cathedral organ sits directly on top of the screen in the centre of the building. It was completed in 1665 by John Loosemore.

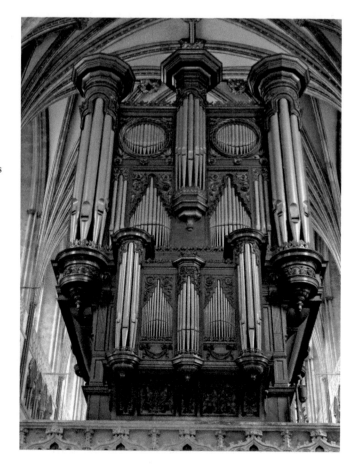

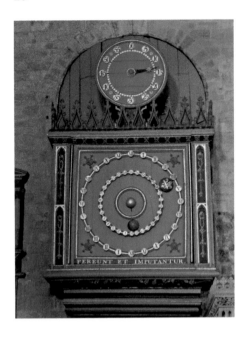

Exeter's astronomical clock shows the state of scientific knowledge when it was built in the late fifteenth century, with the earth in the centre of the universe and the sun and moon revolving around it.

one which had been vandalised during the Civil War and Commonwealth periods. It was built by John Loosemore, who completed it on 27 May 1665, at a cost of £847 7s 10d. In gratitude for his work, Loosemore was buried in the cathedral following his death in 1681.

Astronomical Clock

Built in 1484, the Exeter Astronomical Clock is a fascinating look back into the past. The outer disc shows the hours of the day, while the inner disc displays the phase of the moon and the day of the lunar month. However, a close look reveals that it's actually a model of how people thought the solar system worked at the time, with the earth in the centre, the moon revolving around it and the sun going around outside that. It wasn't until nearly a century after the clock was built that Copernicus and others started to suggest it was actually the sun that everything revolved around, so this clock doesn't just tell the time, but also gives us an insight into how people thought the world worked at the time it was built.

DID YOU KNOW?
The nursery rhyme 'Hickory Dickory Dock' is said to have been inspired by the Exeter Astronomical Clock and more particularly the fact that the room the clock mechanism is kept in has a hole cut into its door. Legend says the cathedral had a constant problem with mice and rats gnawing the clock machinery (largely because they were covered in fat to keep them lubricated), and so in the seventeenth century a hole was cut into the door to allow the cathedral cat in to hunt. This is said to have inspired the nursery rhyme, which is first recorded in print in the mid-eighteenth century.

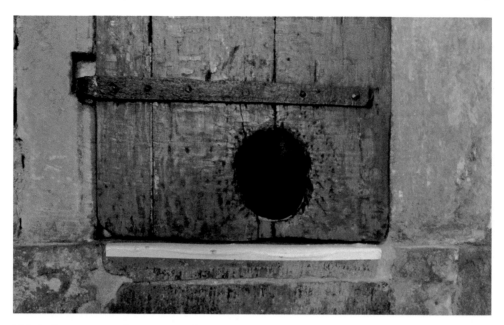

This hole was cut in the seventeenth century to allow a cat to get into the room that contains the astronomical clock's machinery. It is believed to have inspired the nursery rhyme 'Hickory Dickory Dock'.

St James Chapel

A small quiet part of the cathedral, St James Chapel doesn't particularly stand out from the rest of the building, looking perfectly in keeping with the medieval surroundings. However, what not everyone realises is that it's actually less than a hundred years old. During the Blitz in 1942, the cathedral suffered a direct hit, with a bomb destroying the original chapel along with several buttresses and causing other ancillary damage. The chapel was then reconstructed in the original style. There are a few secret details that betray its more modern construction, not least the carving of a rugby player's face, which commemorates a 1951 match between Exeter Rugby Club and the University of Oxford that raised money for the restoration.

Exon Domesday

Most people have heard of the Domesday Book, William the Conqueror's massive survey of his lands in England, which offers an incredible record of the places, names, people, and what was on the land at the time. However, less known is that in order to get the survey done quickly in 1086, the country was split into sections. The Exon Domesday, held in Exeter Cathedral Library, is the sole surviving copy of the 'Little Domesday' area that covered Cornwall, Devon, Dorset, Somerset and Wiltshire. While some of the information is also contained in the Domesday Book, the Exon Domesday features far more detail; indeed, despite being incomplete it's longer than the entirety of the Domesday Book. It is the most extensive record of the Domesday survey in existence, giving an unparalleled insight into the south-west of England in the late eleventh century.

Despite looking medieval, St James' Chapel is a modern reconstruction after the original chapel was destroyed by a German bomb during the Second World War.

The Exeter Book

It may be the single most important object in Exeter, but if you randomly asked residents of the city about it, most have probably never heard of it. Also held in Exeter Cathedral's library, the Exeter Book (also known as the Exeter Book of Riddles) is the largest known collection of Old English literature still in existence, and one of only four major codices of Anglo-Saxon literature in the world. It contains a miscellaneous collection of poetry that was written down by a single scribe (probably a monk) around AD 970.

The poetry ranges from a depiction of a man alone at sea to a wife lamenting the loss of her husband. More famously though, the book contains a collection of around ninety riddles. Perhaps most surprisingly for a book written down by a monk and gifted to the cathedral by a bishop, the riddles are full of double entendre, with the text often deliberately sounding like it's talking about something rude, while the actual answer is more mundane (see the example below). Also interesting is that the answer to many of the riddles has been lost in time, with historians now arguing about what they refer to.

The Exeter Book has an incredible legacy of inspiring other writers, not least that it helped give us Tolkien's Middle Earth. J. R. R. Tolkien was a philologist who studied language and particularly older versions of English – he was therefore very interested in the Exeter Book. It's thought that a line from the Exeter Book poem 'Christ I', 'Hail Earendel brightest of angels, over Middle Earth sent to men', gave Tolkien both the name of the realm the Lord of the Rings would be set in, and the half-elf, half-man character Eärendil.

It is such an important artefact that in 2016 it was included in UNESCO's Memory of the World register as one of the 'world's principal cultural artefacts', alongside the Diary of Anne Frank, Magna Carta and the Bayeux Tapestry. It has also been referred to as the 'foundation volume of English literature'.

Exeter Book Riddle 25:
'A curiosity hangs by the thigh of a man, under its master's cloak. It is pierced through in the front; it is stiff and hard and it has a good standing-place. When the man pulls up his own robe above his knee, he means to poke with the head of his hanging thing that familiar hole of matching length which he has often filled before.'

Answer: A key

DID YOU KNOW?
R. D. Blackmore (1825–1900), author of the celebrated West Country novel *Lorna Doone*, has a memorial in Exeter Cathedral. He was not, in fact, from Exeter himself though. He was born in Longworth in what is now Oxfordshire. The memorial was installed four years after his death in recognition of his strong West Country connections.

A Church City
There are many churches in Exeter, each with their own fascinating history, but sadly there's not room in this book to cover them all. Instead here are a few things about them you may not know or may never have spotted.

St Pancras Church (Guildhall Shopping Centre)
St Pancras is so familiar to many Exeter residents that they fail to really look at it – after all it is a fairly nondescript old building with small windows and little on the outside to distinguish it. For many visitors, however, it can't fail to stand out as it's a tiny, ancient church in the middle of the modern Guildhall Shopping Centre. What few realise is that it wasn't preserved solely because the present building was largely built in the thirteenth century, but also because it may be the oldest Christian site in Exeter, with evidence it has been in use since the mid-Saxon age and possibly before. Most also fail to notice it has three square corners and one rounded one. This chamfering was to make it easier for horses and carts to get past in the days before it was in a shopping centre!

St Mary Steps Church (West Street)
A small and pretty church at the foot of Stepcote Hill, St Mary Steps most fascinating but oft-forgotten feature is the Matthew the Miller clock. Built in 1619–21 by Matthew Hoppin (although it now has a mechanism that was installed a century later), above the

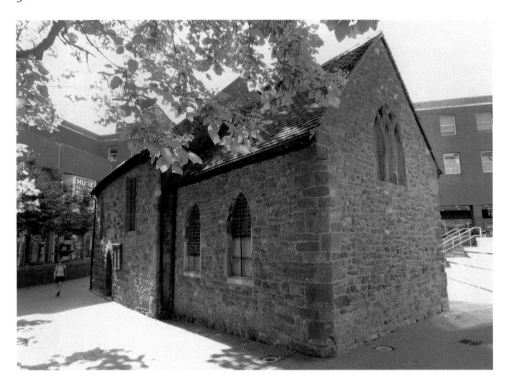

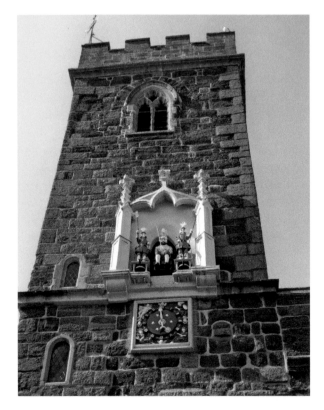

Above: The ancient St Pancras Church may be the oldest Christian site in Exeter, but is now landlocked in the middle of a modern shopping centre.

Left: The Matthew the Miller clock on the tower of St Mary Steps Church is believed to be based on a real miller who was fastidious in his timekeeping.

clockface are depicted a seated man and two heralds, who are believed to be Matthew the Miller and his sons. The sons strike small bells on the quarter hour, while Matthew leans forwards while a larger bell strikes on the hour. Folklore says there was a real Matthew the Miller who worked at the nearby Cricklepit Mill and was known be fastidious in his timekeeping, so in tribute he was carved into St Mary Steps' new clock.

The clock also inspired a rhyme:

> Matthew the Miller's alive
> Matthew the Miller's dead
> But every hour on West Gate Tower
> Matthew nods his head

George's Meeting House (South Street)

George's Meeting House hasn't been a place of worship since 1983, and has now been converted into a pub. Even so, there's no hiding its religious past, with stained glass in the windows and an ornate pulpit dominating the main room. The pulpit actually predates the building, as it was brought in from an earlier Unitarian Meeting House when George's was opened in 1760. Anyone who has sat in the upstairs gallery will also have noticed that while staircases allow you to go up to either side, barriers block off the back portion that links the two. The reason for this is that the platform and step at the rear of the gallery is a rare original survival from the earliest days of the chapel. As it is rather delicate, it has been blocked off to protect it. Although it's now a pub, the fact it's so comparatively unaltered from its earliest days means it has been given Grade I-listed status.

St Stephen's Church (High Street)

Sat in the middle of the High Street, St Stephen's looks like it always was and always has been a church. However, that's not quite true. The site has been a place of worship for well over a thousand years, with evidence of Saxon, Norman and medieval phases in its construction. However, that came to an abrupt halt following the Civil War, when Cromwell decided numerous churches in Exeter should be closed and sold off. The result was that in 1658, Toby Allen bought it for £230 and used it as a stable, most probably to hold the donkeys that brought goods into and out of town. It could have been a rather ignominious end for a very ancient site of worship, but not long afterwards, during the Restoration, it was rebuilt as a church (despite a fire that almost destroyed it completely).

Church of St Mary Major (Cathedral Green)

This church doesn't exist anymore, but it's worth mentioning as despite being a prominent fixture on the Cathedral Green until 1971, it has been almost completely forgotten and to many younger people it will seem inconceivable it was ever there at all. St Mary Major occupied most of the now open area in front of the west entrance, between the Devon War Memorial and the Deanery. It was built on the site of the original Saxon minster, which became Exeter's first cathedral. However, by the mid-twentieth century it was deemed

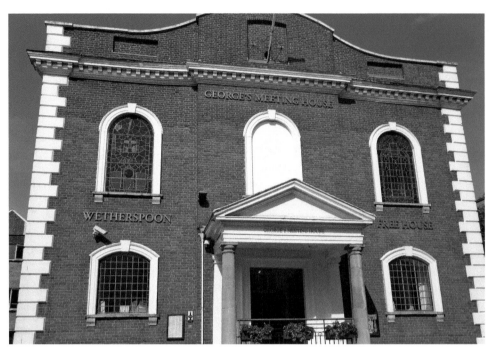

Now a pub, George's Meeting House retains so many of its rare original eighteenth-century Unitarian chapel features that it has been given a Grade I listing.

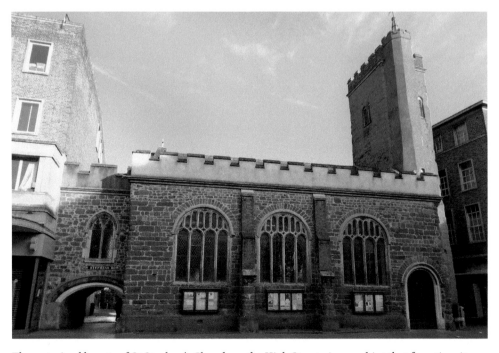

The restrained beauty of St Stephen's Church on the High Street gives no hint that for a time it was used as a stable for donkeys.

unnecessary and so it was demolished, with hopes of replacing it with an underground car park. However, the discovery of Saxon burials and a Roman bathhouse underneath it put an end to those plans. By that time, though, the church itself had already been knocked down. Many will be surprised that while the Cathedral Green looks like a place that's fixed in time, just fifty years ago it looked very different.

St Olave's Church and St Nicholas' Priory (Fore Street)

St Olave's Church at the top of Fore Street is almost entirely ignored. Indeed, due to its high windows and small door, many people walking past may not even realise what it is. However, it is one of Exeter's most beautiful ancient churches, and may have been founded by Gytha, mother of King Harold (of Battle of Hastings fame) in the eleventh century. Later on William the Conqueror gave the church to the monks of Battle Abbey, which William had founded to help atone for the bloodshed at Hastings. Those monks then founded St Nicholas' Priory, just off Fore Street, in 1087. The priory was used by the Benedictine order for over 500 years, until it was shut down during the Reformation. Afterwards some of the cloistered buildings were torn down, but some remained, being used for various purposes from schoolhouses to private residences. These buildings still exist and can sometimes be visited by the general public.

Legend says that St Olave's Church was founded by Gytha, mother of King Harold.

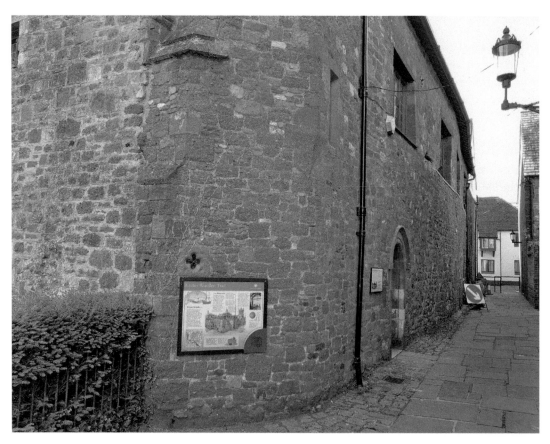

Hidden away between Fore Street and Bartholomew Street, parts of the medieval St Nicholas' Priory still exist and are often open to the public to view.

3. Trade in Exeter

It may seem strange to say but the success of Exeter was built on wool. Until the early nineteenth century Devon was at the heart of the textile industry and Exeter was the centre of that. Wool was brought into the city from all over the south-west and mainly sold to local manufacturers who would process and weave it into cloth within the city. It's thought that in 1700, over 1,200 people in Exeter were employed as weavers, with thousands more employed in ancillary industries.

Evidence of just how important wool was to Exeter is that in the sixteenth century around half of the elite freemen who entered the city's guilds were involved in the wool/cloth industry. It's no coincidence either that while most of the meeting places of the various guilds have disappeared over the years, the magnificent Tuckers Hall, which still belongs to the Guild of Weavers, Tuckers and Shearmen, remains on Fore Street. This remarkable but largely overlooked building dates from the late fifteenth century, with additions and embellishments added over the course of several hundred years. It still

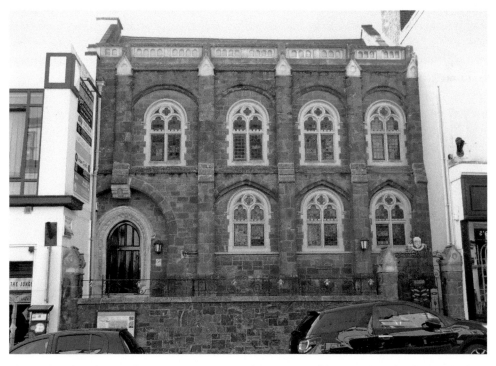

The medieval Tuckers Hall on Fore Street is one of the most visible reminders that for hundreds of years the economy of Exeter was built on wool.

retains its sixteenth century oak panelling and highly decorated medieval wooden barrel roof. It is evidence of the wealth and power that wool bestowed at the time.

By the eighteenth century cloth from Exeter (mainly a type known as serge) was so popular that local farmers couldn't keep up with the city's demand for wool, and it had to be imported from Ireland.

The amount of power, prestige and money involved in the industry meant that there were constant battles in Exeter between different factions. The weavers often felt at the mercy of the merchants, while the small farmers who produced the wool in the first place often felt they weren't given a fair price for it. However, the biggest fights were for control of the economy of Exeter itself, and that was largely between the church, the guilds/freemen and local aristocracy, the earls of Devon.

Controlling the River

Perhaps the longest battle in Exeter's history wasn't about violence or land, but about money. From Roman times Exeter had two main docks: one next to the city at what is now Exeter Quay, and an outport at Topsham. By the medieval period the quay was controlled by the city, while Topsham was the property of the earls of Devon. This caused tension between the two sides, as both of them made money from the goods that came into and out of their docks and so both wanted as many boats to come to them as possible.

The two rubbed alongside one another until the late thirteenth century when Isabella, Countess of Devon, built a weir across the river – which soon after gave its name to the Countess Wear area, a couple of miles downstream from the city walls. There is dispute over whether this act alone blocked access for boats to pass Topsham and dock in Exeter, or whether Isabella left a gap in the weir that was filled in by one of the next two earls of Devon, both of whom were named Hugh de Courtenay. What is certain is that by the mid-fourteenth century boats could no longer sail all the way to Exeter, forcing them to load and unload at Topsham. This made the Courtenay's plenty of money but infuriated the people of Exeter. It ensured Topsham became a prosperous place and remained a significant port until the early twentieth century. The town's current picture postcard image of Dutch gabled former merchant's houses is a legacy of the wealth it once had as a seaport, as well as a centre for fishing and shipbuilding.

The weir not only affected the burgeoning woollen industry, but also what may have been as big a part of Exeter life at the time: fishing. Historical records suggest the Exe was once brimming with salmon, and that fishing in general was a large industry in the area. However, the weir disrupted the migration routes and devastated the salmon fishing industry.

For the next 200 years the city tried to get the river reopened. The earls weren't interested in helping as they were too busy profiting from the arrangement. Even numerous petitions to the king by the people of Exeter fell on deaf ears. Then history stepped in in 1538 when another Earl of Devon, also called Hugh Courtenay, was arrested on suspicion that he was part of a conspiracy to overthrow Henry VIII and install himself on the throne instead.

Hugh had been a favourite of Henry, who'd even made him Marquess of Exeter. However, the earl became increasingly critical of Thomas Cromwell's actions during the

Reformation and faced criticism for the fact his wife was a steadfast Roman Catholic. As a result, there was increasing suspicion of him, not helped by rumours that he was so popular with the people of Devon and Cornwall that many wanted Henry to disinherit his children and name Hugh his successor. Cromwell managed to convince Henry that Hugh was involved in a Catholic plot to overthrow him, spearheaded by the self-exiled Cardinal Reginald Pole. There was little evidence against Hugh, but he was still convicted and beheaded. The entire affair became known as the Exeter Conspiracy.

All this high state intrigue may have been bad for the Courtenay family, but it was good for the people of Exeter, as with the Courtenays out of favour, in 1550 Edward VI gave permission for the weir to be breached. Unfortunately, though, by that time the previously navigable channels had silted up and boats still couldn't reach the city itself.

DID YOU KNOW?
Between 1971 and 1980, TV audiences enjoyed *The Onedin Line*, a popular drama based around the ups and downs of a fictional shipping company in late Victorian England. The series was set in Liverpool but for many scenes, particularly those set on the docks, Exeter's Quayside was used.

A First Canal and the Rebirth of the Quay

Despite still not being able to get boats all the way up the river to Exeter, those in charge of the city were not deterred. In the 1560s they embarked on something that had never been tried in Britain before and could have been an enormous folly: the Exeter Ship Canal. While many people have taken a pleasant walk, cycle or even boat ride along the canal, few of them realise it's one of the first man-made waterways in the UK.

Exeter traders employed Scottish engineer John Trew to build the canal, which originally ran one and three quarter miles from just below the quay to just below the breached Countess Weir. Construction included the very first pound locks ever built in England to raise and lower boats. It took around three years to build and opened in late 1566 or early 1567, early in the reign of Elizabeth I. The weir just below Exeter Quay, which ensures the water level of the river remains the same as the canal, is named Trews weir after John Trew.

Even then all was not well, as the new canal was difficult to navigate and couldn't be entered at all at certain times of the day due to the varying tides. Consequently, the hoped-for boom in trade taking place directly in Exeter didn't materialise. In order to rectify this, in the late seventeenth century the entrance to the canal was moved further downstream to Topsham, while in the early eighteenth century it was deepened and widened to allow the passage of much larger ships.

Finally, 400 years after Countess Isabella had her weir built, sea-going ships could reach Exeter and it could successfully operate as a port. The much-improved canal was a great success, which you can see hints of as you walk down it. The still existing

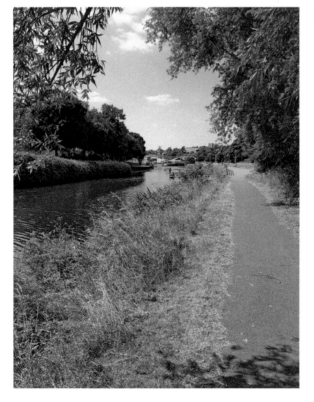

Above: The fight to be able to get boats past Topsham and all the way to Exeter shaped trade in the city for over 400 years.

Left: The quiet peace of the Exeter Ship Canal gives few hints that it is one of the first man-made waterways in the UK and revitalised Exeter's economy.

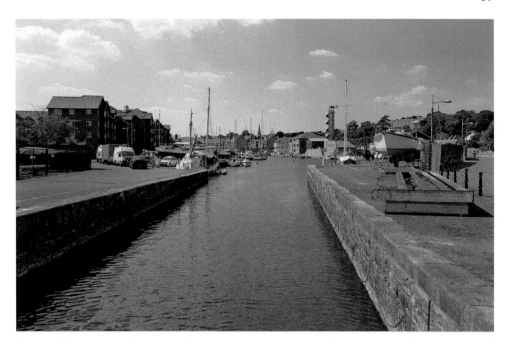

The canal basin was built in the eighteenth century in order to better control the increasing flow of large, seagoing ships that were docking in Exeter.

wider areas, lakes/broads and canal basin for boats to turn in show how much need there was to control the growing flow of traffic up and down the canal, with cotton, dyes, wools and other goods being brought in from overseas and finished cloth being exported back out (particularly from and to the Netherlands, which was Exeter's main trading partner).

The nineteenth-century warehouses on the quay are evidence of this boom time. Many of them still show signs of their original use, and if you look up you can see the remains of the pulley systems that once lifted and lowered goods from the quayside into the warehouses. Indeed, the whole quay is a bit of a time capsule of trade in Exeter from the seventeenth to the nineteenth century.

For example, the open-sided building right next to the river could be mistaken for an oversized bandstand – especially as that's what it's often used as on Sunday afternoons in the summer – but it and the adjoining building (now an antiques shop/café) were originally an early nineteenth-century transit shed. Directly behind that building is another even older transit shed, now known as Quay House. Regular visitors to the quay will know that this building appears to be set into the ground and has steps down to it that don't appear to lead anywhere. The reason for this is that historically the quayside was lower and closer to this building. Therefore, the front of Quay House shows where the ground level was when it was built in the 1680s.

Next door to that is the Custom House, which was built around the same time as Quay House and is believed to be the oldest remaining brick-built building in the city. This rather beautiful building shows just how important Exeter had become as a port.

Despite often now being used as an improvised bandstand, this open-sided building on Exeter Quay was originally a nineteenth-century transit shed.

The peculiar 'steps to nowhere' on the late seventeenth-century Quay House show that the ground level of the quay used to be much lower.

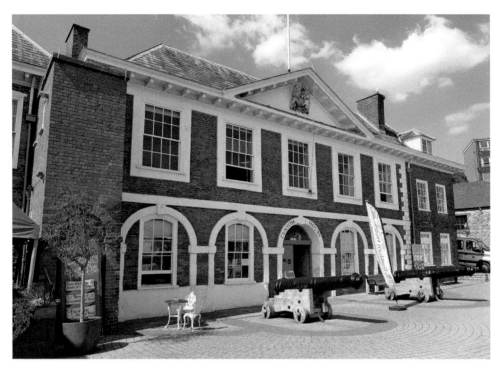

The Custom House is believed to be the oldest brick-built building still remaining in Exeter.

Previously trade was at a level where excise duty could be calculated and collected elsewhere in the city (and even for a time down in Topsham). However, in 1680 it was decided that the quay needed its own specially built Custom House.

Further down the quay are a series of 'cellars' that now contain craft shops and artisans. These were originally warehouses, built in the early nineteenth century by excavating directly into the sandstone cliff. On the opposite side of the quay in the area now known as Piazza Terracina is a round area that could easily be mistaken for modern seating. However, it is actually the remains of a Victorian railway turntable used when engines brought goods to and from the quay.

DID YOU KNOW?
By the end of the nineteenth century the 'cellars' built into the cliff next to the quay were increasingly being used to store flammable liquids. While some, including the residents of Colleton Crescent at the top of the cliff, were concerned about this, nothing was done to stop it. The result was a massive explosion on the morning of 2 December 1882, when vapours from barrels of petroleum caught fire, which then spread to other cellars also containing flammable liquid. Miraculously, no one was seriously hurt.

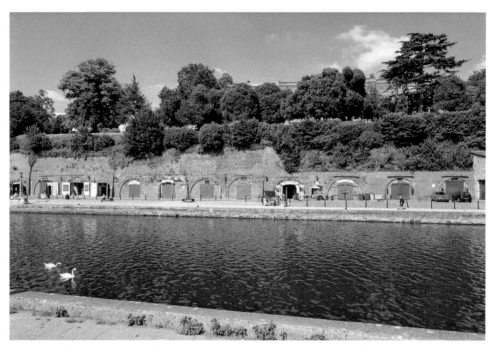

The quay 'cellars' were originally nineteenth-century warehouses dug directly into the sandstone cliff.

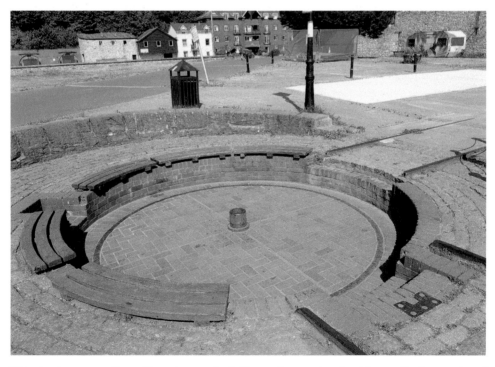

This circular area on Piazza Terracina may look like modern seating, but it's actually the remains of a nineteenth-century railway turntable. The tracks that once led from it are still visible.

By the nineteenth century, the wool trade in Exeter had shrunk massively (not least when exports were massively disrupted by the Napoleonic Wars), accelerated by the Industrial Revolution shifting the focus of cloth weaving northwards. As a result, less and less trade was done via Exeter's quay. When the railways arrived in 1844, this offered an often more convenient and cheap way to move goods around. The city limped on as a port into the twentieth century with ever-decreasing traffic, until 1971 when the last commercial vessel unloaded its cargo on the quayside.

DID YOU KNOW?
Just outside the Custom House sit two cannon, but what are they doing there? They were two of a batch brought to the city in the nineteenth century on the understanding they had been used at the Battle of Waterloo in 1815. By the time they arrived in Exeter, four of them had already been earmarked for use at the Wellington Monument in Somerset, which was being built from 1817 onwards. However, it turned out they'd never been used at Waterloo. They had actually been sold to the Russians in the 1780s to arm their fleet before later being returned after Napoleon's defeat. When this was discovered, those involved in the Wellington Monument decided they no longer wanted them. When no other uses or buyers could be found, the council decided to use four of the cannon as bollards, buried upright into the ground in front of the quay cellars (yes, bollards!), and to simply bury the rest. They were excavated in the twentieth century, with four finally being accepted for display at the Wellington Monument. Of the rest, most were melted down during the Second World War to make munitions. However, two cannon remain, which are now stationed outside the Custom House.

4. Intrigue and Murder in Exeter

Over the last 2,000 years it's perhaps not surprising that Exeter has occasionally been caught up in intrigue, conspiracies, crime and murder. As we've already seen, Roman prefects refused their orders, the earls of Devon set themselves at odds with the city and Exeter refused to accept the result of the Battle of Hastings. However, that's only the beginning of the city's secret world of intrigue, which includes murderous mayors, supposed witches and Protestant martyrs.

A Mayoral Conspiracy

As mentioned in the last chapter, the authorities in Exeter and the local aristocracy often found themselves at odds. However, it was the guilds/councils and the church that represented the two main powers within the city for hundreds of years, with their different approaches to things often causing problems. For example, the cathedral precinct was one of the few areas where the city's council had no powers, which caused issues when criminals and other ne'er do wells realised they could take refuge there and the clergy were unlikely to care.

However, things got really serious in the 1280s when an internal cathedral dispute spilled over into murder. Although some mystery remains as to what really happened and who was involved, what is certain is that the new Bishop of Exeter, Peter Quinil, got into a massive feud with a man called John Pycot. Pycot had managed to get himself elected to the position of cathedral dean in Quinil's absence. The bishop didn't want Pycot as dean and so ruled the vote by the chapter invalid. Pycot wouldn't accept this though, and this set off a years-long feud, with both sides sending entreaties to the Archbishop of Canterbury and Pycot even heading to Rome to try to get support from the Pope.

To strengthen his position, Bishop Quinil then elevated a supporter called Walter Lechlade to the position of precentor. Pycot was singularly unimpressed with this, possibly believing that Quinil was manoeuvring to make Lechlade the dean instead of him.

On the morning of 9 November 1283, Lechlade left the cathedral after mid-night matins and headed towards his house at the Chantry (on the site where part of Exeter Cathedral School now stands on Bear Street). He was set upon by a group of assailants who savagely attacked and killed him. The attack was so ferocious that Bishop Quinil later said, 'Their horrible outrage was seen by many – his canonical robe soiled with blood and his brains issuing from two ghastly wounds.'

Suspicion immediately fell on John Pycot, and perhaps more surprisingly, the city's mayor, Alured de Porta. The suspicion was that the two men had hatched the plan together, as de Porta was a supporter of Pycot (or it may have been more that de Porta was against Quinel, who appears to have been quite a didactic man who believed things

Right: Now part of Exeter Cathedral School, this site on Bear Street was previously the Chantry where the murdered precentor William Lechlade lived.

Below: William Lechlade had just come through the gate of the Bishop's Palace following midnight matins when he was murdered.

should be done his way and no other). De Porta would also have had the connections and ability to get the killers in and out of the city without detection.

Despite the obvious suspects, no prosecutions were brought, which led to Quinil appealing to Edward I's mother for justice. That resulted in the king himself coming to Exeter in order to get to the bottom of things. In the end, charges were brought against a total of twenty-one people including Pycot and de Porta. None of these people were said to be part of the gang who committed the actual murder but all were accused of being involved in the conspiracy, including the porter who supposedly allowed the murderers through the South Gate.

Edward commenced the trial on 24 December 1285 in the Great Hall of Exeter Castle. It appears that the king was quickly convinced of the mayor's involvement, as following an adjournment on Christmas Day, the trial recommenced on the 26th. It was on that day the mayor was found guilty and executed by hanging. Four others were executed as well for their part in the conspiracy.

Pycot was also believed to be guilty, but like many of the other cathedral staff who had been charged he plead 'benefit of clergy'. This meant his punishment was dished out by the ecclesiastical authorities instead of the Crown. As a result, he submitted to 'canonical purgation', a system where if you swore you were innocent in front of enough reliable witnesses, you would be allowed to go free. The idea was that if you lied you would be ensuring eternal damnation, and that no one would want to do that. However, it meant that, in this life at least, you could get away with murder as long as you were a 'man of God'.

The Devon Witches

One of Exeter's better-known secrets is that it's believed to be the last place in England to execute anyone for witchcraft. However, far fewer know the actual story. In 1682, Temperance Lloyd, Susannah Edwards and Mary Trembles were elderly women living in Bideford. Lloyd was accused by the locals of 'having discourse or familiarity' with the Devil and that she had 'used some magical art, sorcery or witchcraft' after Bideford shopkeeper Thomas Eastchurch said he had seen her using sorcery.

Perhaps unsurprisingly, the evidence against Lloyd was largely based on hearsay, gossip and rather spurious supposition. Lloyd's case centred on an illness that a woman called Grace Thomas had in September 1681, which she suspected Lloyd was responsible for as Temperance had been so pleased to see that she recovered. Grace's brother-in-law Thomas Eastchurch then backed this up by saying he'd overheard Lloyd confess to meeting 'something in the likeness of a black man' who convinced her to hurt and try to kill Grace. There was no direct evidence of any wrongdoing, but others suggested they may have been hurt by Temperance, and she was also accused of several murders dating back to 1671.

A woman called Anne Wakely testified that she'd discovered the Devil's mark on Lloyd's body in the form of two extra teats 'in her secret parts'. She also said Lloyd had been visited by the 'black man' in the form of a magpie, who had suckled at her extra teats.

Two weeks after Lloyd was arrested, Mary Trembles was accused of causing the fits of a woman called Grace Barnes, as Mary had been seen near her house. This descended

into hysteria when a man who helped carry Grace to the town hall to give evidence against Trembles shouted, 'I am now bewitched by this devil.' He then leapt about 'like a madman, quivering and foaming, and lay there for the space of half an hour like a dying or dead man'.

Susannah Edwards was also arrested as she was known to beg with Trembles. Soon people were found to accuse her of witchcraft too, most of whom claimed to have overheard her confessing various things, such as having carnal knowledge of the Devil.

At various points all three women confessed to witchcraft, with Trembles blaming Edwards and Edwards passing the blame onto Lloyd. Public opinion suggested Lloyd was the ringleader who'd pulled the other two into devilry. This wasn't helped by the fact that while the other women recanted, Lloyd never fully did (even if her statements were contradictory).

The three women were brought to Exeter and held at the Devon County Gaol next to the castle (on the site of what is now the Timepiece nightclub). In August 1682, they were hauled in front of the Assizes Court at the castle. All three plead not guilty, but when examined they confessed to being involved in witchcraft. As a result, they were convicted, taken to the gallows at Heavitree and hanged.

Now the Timepiece nighclub, this site just off Little Castle Street was formerly the gaol where the Devon 'witches' were held in the run-up to their trial.

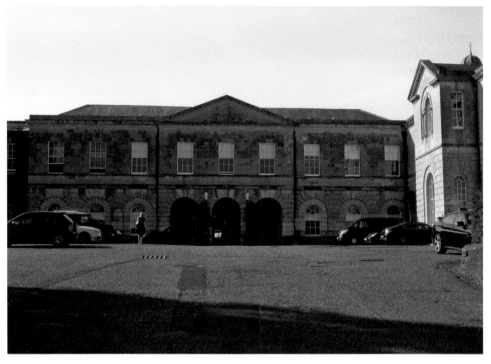

A Georgian former court building now sits on the site of the earlier Exeter Castle, where the Devon 'witches' were tried.

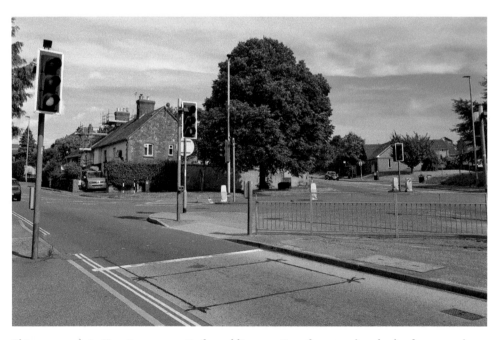

This crossroads in Heavitree was a site for public executions for many hundreds of years, and was where the Devon 'witches' met their end.

Even with her execution imminent, Lloyd was still saying that she had known the Devil. More recently the case has been re-examined and many now believe that these women – who even at their own trial were described as 'very old, decrepit and impotent' – were suffering from dementia, and became scapegoats for an extremely superstitious populace who were looking for supernatural answers to things they didn't understand.

They weren't quite the final women to be executed for witchcraft, as in 1685 Alice Molland was also convicted in Exeter and hanged. Comparatively little is known about the particulars of her case, but she appears to have been the very last.

The four women are commemorated with plaques both in the Timepiece bar and on the walls of Exeter Castle.

In the last few years a new Exeter secret has been discovered, with historian Mark Stoyle stating in his book *Witchcraft in Exeter: 1558–1660* that Exeter may have also been the site of the first execution for witchcraft too. In 1553, the law was changed to say that those convicted of 'conjurations, enchantments and witchcrafts' should be put to death. In 1556, Maud Park and Alice Mead were put on trial in Exeter for causing death and physical injury by means of witchcraft and were convicted. Although no specific record of their execution has been found, it is presumed that this is the fate they met. If it was, it means they were likely the first people executed for witchcraft after the change in the law.

Between then and 1660, Stoyle found evidence of more than twenty other people who were put on trial for witchcraft in Exeter. Nearly all were women, although one man was accused. The vast majority were found guilty.

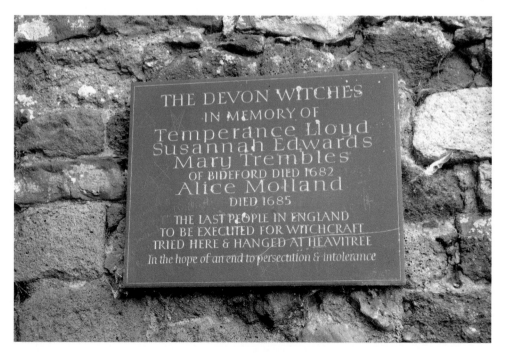

A plaque on the wall of Exeter Castle commemorates Temperance Lloyd, Susannah Edwards, Mary Trembles and Alice Molland, the last people to be executed for witchcraft in England.

While Alice Molland may have been last person executed for witchcraft in England, the death penalty for witches wasn't abolished in England until 1736.

Martyrs

On the corner of Barnfield Road and Denmark Road is a small obelisk memorial that most people pass without a second look. Even those reading the inscription on the front won't get much of a picture of what it commemorates. It reads, 'IN GRATEFUL REMEMBRANCE OF THOMAS BENET, M.A. WHO SUFFERED AT LIVERY DOLE, A.D. 1531, FOR DENYING THE SUPREMACY OF THE POPE, AND OF AGNES PREST WHO SUFFERED ON SOUTHERNHAY A.D. 1557, FOR REFUSING TO ACCEPT THE DOCTRINE OF TRANSUBSTANTIATION. "FAITHFUL UNTO DEATH".'

The story behind it shows that while it's easy to imagine sixteenth-century Exeter being a backwater that world history bypassed, at times it found itself in the middle of the tumult of changing ideas.

In 1517 Martin Luther famously nailed his Ninety-five Theses to the door of All Saints' Church in Wittenberg as a way of underlining his objections to certain practices in the Catholic Church, most notably the practice of selling indulgences, where priests could

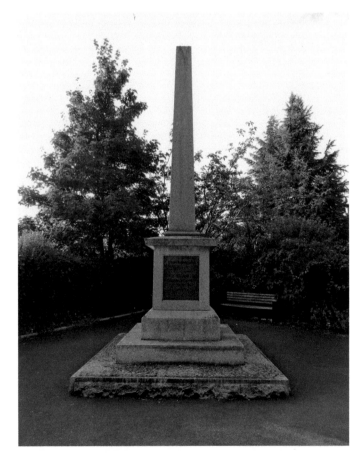

A memorial to protestant martyrs Thomas Benet and Agnes Prest sits on the corner of Denmark Road and Barnfield Road, halfway between the sites of their executions.

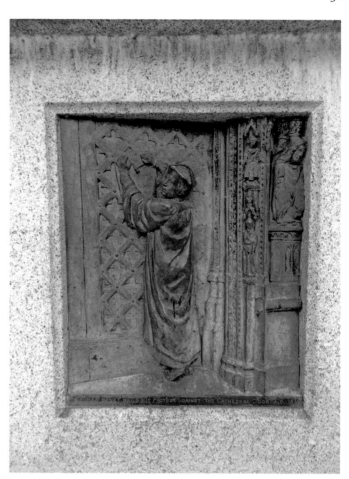

A plaque on the side of the Exeter martyrs memorial depicts Thomas Benet nailing his objections to the Catholic Church to the door of the cathedral.

supposedly forgive the sins of both the living and the dead in exchange for cash. It kicked off the Protestant Reformation and Luther's ideas quickly spread. One person affected was a man in Cambridge called Thomas Benet.

Benet decided to reject the traditional Church teachings and in 1524 moved to Torrington in Devon in the hope he could practice his nonconformist beliefs somewhere out of the way where no one knew him. He then moved to Exeter where he became a schoolteacher.

Following in Luther's footsteps, in 1531 he began nailing his own objections to the established church to Exeter Cathedral's door, including such potentially incendiary statements as, 'The pope is antichrist; and we ought to worship God only, and no saints.'

Unfortunately, his son was discovered in the act of posting these bills, which led to Thomas being imprisoned. He refused to recant his beliefs and as a result he was convicted of heresy and sentenced to death. Numerous priests and others tried to get him to change his mind, a process that continued right up until the point he'd been tied to the stake at Livery Dole in Heavitree.

According to (the often inaccurate) Foxe's Book of Martyrs,

Thomas Carew and John Barnehouse, standing at the stake by him, first with fair promises and goodly words, but at length through rough threatenings, willed him to revoke his errors ... the aforesaid Barnehouse was so enkindled, that he took a furze-bush upon a pike, and having set it on fire, he thrust it unto his [Benet's] face, saying, 'Ah! whoreson heretic! Pray to our Lady, and say, Holy Mary, pray for us, or, by God's wounds, I will make thee do it.' To whom the said Thomas Benet, with a humble and a meek spirit, most patiently answered, 'Alas, sir! Trouble me not'. And holding up his hands, he said, 'Father, forgive them.' Whereupon the gentlemen caused the wood and furzes to be set on fire, and therewith this godly man lifted up his eyes and hands to heaven, saying, 'O Lord, receive my spirit.' And so, continuing in his prayers, did never stir nor strive, but most patiently abode the cruelty of the fire, until his life was ended.

Shortly after Benet was executed, Henry VIII turned the whole country away from the Catholic Church and set off the English Reformation, but by then it was too late for Thomas. The conflict between Catholicism and Protestantism continued to rage down the decades, so that Agnes Prest was also caught at the wrong moment in history.

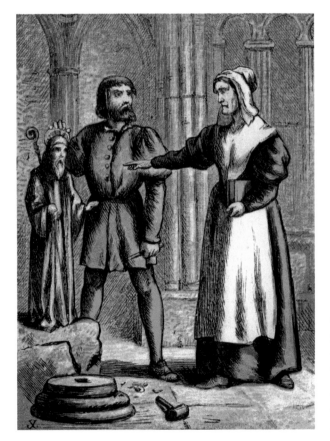

This illustration from a nineteenth-century edition of Foxe's Book of Martyrs depicts Agnes Prest telling a cathedral stonemason he shouldn't repair the statues as Protestantism was returning and they'd just be destroyed again.

Following Henry VIII's death in 1547, 'Bloody' Mary I took the throne in 1553 and began to violently reverse her father's actions and to re-establish Catholicism as the one true faith in England. However, down in Cornwall, Agnes was having issues with Catholic dogma. Her biggest problem was with transubstantiation – the idea that once it is blessed, the bread and wine of communion literally becomes the body and blood of Christ. While her staunchly Catholic husband tried to convert her back to the Roman Church's view, she refused to give up her beliefs. As a result of her heretical ideas, she was locked up in Launceston Prison before being transferred to Exeter Prison.

According to Foxe, some of her supporters managed to convince the bishop she was mad, and so she was freed. However, due to the fact she continued to deny transubstantiation and also suggested that Protestantism was soon going to return as the dominant religion, she was locked up again. Agnes became a bit of a cause celebre, being visited by various dignitaries including the wife of explorer Sir Walter Raleigh. However, this time there was no saving her as she was tried and convicted of heresy. Agnes was taken to Southernhay, tied to a stake and burned to death on 15 August 1557. Just one year later, Mary I died and her half-sister Elizabeth I ascended the throne, bringing back Protestantism just as Agnes had suggested.

The small memorial that commemorates Thomas and Agnes in Exeter wasn't erected until 1909.

The quiet peace of modern Southernhay gives no hint that it was once the site of Agnes Prest being burned to death at the stake.

5. War in Exeter

In the past 2,000 years war has touched Exeter on several occasions. That includes some perhaps surprising connections to key moments in British history, as well as lots of bloodshed and suffering. The city survived through sieges and rebellion, before experiencing its worse devastation in over a thousand years in the spring of 1942.

King Stephen and the Earl of Devon

In 1135 Henry I died, after which his nephew, Stephen, seized the throne, an act that set the country on the path to civil war. One baron who did not agree with Stephen's power-grab was the Earl of Devon, Baldwin de Redvers, who felt the new sovereign should have been Henry's daughter, Matilda. In support of Matilda, de Redvers occupied Exeter Castle in 1136. Stephen decided that he couldn't permit this to stand, as if he didn't nip the earl's actions in the bud, the armed support for Matilda could easily spread further across the south-west.

Stephen marched on Exeter and laid siege to the town. It is this siege that is believed to have resulted in the fortifications at Danes Castle, which were either a protected outpost of Exeter Castle meant to act as a forward position or built by Stephen during the siege. Despite massive efforts from the king's forces, including attempts to tunnel under the walls, they could not breach Exeter's defences.

The three-month siege only came to an end when the castle's wells ran dry and so did de Redvers' other supplies. At that point, the baron negotiated his men's surrender. This was a key early moment in what later became referred to as the Anarchy: a civil war that raged across England until peace was restored in the 1150s.

Perkin Warbeck: Pretender to the Throne

In the late fifteenth century, towards the end of the Wars of the Roses, a man named Perkin Warbeck spent several years travelling around Europe trying to gather support for the idea that he was, in fact, Richard of Shrewsbury, Duke of York. Richard had been one of the two 'princes in the Tower' who had vanished after being locked up in the Tower of London by Richard III. If he was the prince, it would make him the rightful king of England. He had a surprising amount of success getting people to take him seriously, including numerous European aristocrats as well as some British noblemen. Perkin arrived in Cornwall in 1497 hoping to capitalise on their resentment against Henry VII following his crushing of their own rebellion a couple of years before.

Perkin raised an army of 6,000, had himself crowned Richard IV on Bodmin Moor and marched eastwards, half-expecting to be welcomed into Exeter by disaffected locals. Instead, the city closed the gates and refused him entry. While tradition says Warbeck did eventually manage to force entry to the city before almost immediately leaving again

when he realised no one wanted him there and that overwhelming forces would soon arrive, it appears that actually Perkin never got through the gates and that he lost about a tenth of his army in the first twenty-four hours of the assault. He ended up begging to be allowed to depart peacefully. He fled towards Taunton, but with the Henry's army now bearing down on him, Perkin deserted his own forces (he was shortly afterwards captured at Beaulieu Abbey in Hampshire). Exeter had essentially ended Warbeck's rebellion before it had begun.

Henry accepted the surrender of the rest of Warbeck's army at Taunton before moving on to Exeter to oversee the trials of the ringleaders. In gratitude for the city's loyalty, Henry VII bestowed on it his cap of maintenance and sword, which are still held in the Guildhall.

Civil War: From Parliament to the Crown and Back Again

During the English Civil War, Exeter proved one of the key battlegrounds. That was partially due to the fact that early on it declared for Parliament, partly as a result of having a city council that literally had a puritanical streak. As the most important town in the south-west, this put it firmly in the sights of the Royalist forces, who launched a protracted siege to capture it. The Royalists took the city in 1643 and wasted no time in redefending it as one of their key strongholds.

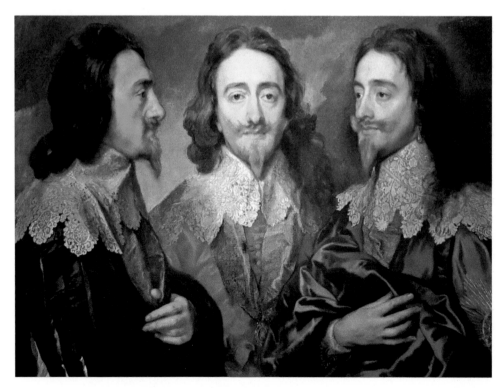

Anthony Van Dyck's famed triple portrait of King Charles betrays little of the tumult that was building around the monarch at the time it was painted.

By 1644, it was considered protected and safe enough that the pregnant queen travelled there from Oxford (where Charles I was then based). Once in Exeter, she gave birth to Henrietta Anne Stuart. Henrietta was the third daughter and ninth child of Charles I, and the younger sister of the future Charles II and James II. She was born in Bedford House, Exeter, on 16 June 1644.

It appears that only two weeks after her birth, Henrietta's mother fled to France leaving the sickly child in Exeter in the care of her governess. Henrietta was only ever seen by her father once and only then when she was a baby. She was nonetheless christened at Exeter Cathedral and lived in the city until the Royalist surrender of Exeter in 1646, after which she went into exile in Paris. In 1661, one year after her brother became Charles II and the monarchy was restored, she married Philippe, Duke of Orleans.

The marriage reportedly was not a happy one. Henrietta lost a number of children in infancy or due to stillbirths or miscarriages, although she had two daughters who survived into adulthood. Henrietta was cultured, a keen gardener and played an active role in securing the Secret Treaty of London between her husband, the duke, and her brother, the king, which led to the Third Anglo-Dutch War.

After years of putting up with her abusive husband's affairs and being forced to wage power struggles with her husband's lovers, Henrietta died suddenly aged twenty-six. While an autopsy attributed her death to peritonitis, Henrietta herself believed she'd

King Charles' pregnant wife, Henrietta Maria, travelled to Exeter to give birth.

This posthumous portrait of Charles I's youngest child, the Exeter-born Henrietta Anne Stuart, still hangs in the Guildhall.

been poisoned. Whatever the truth, it was a sad and premature end to the life of one of the seventeenth-century's most colourful royal women. A portrait of her hangs in Exeter Guildhall to this day.

It is evidence of how important it was thought Exeter was during the Civil War that when it did fall back to Parliament in April 1646, Oliver Cromwell himself came to accept its surrender. The fall of Exeter was one of the key episodes in the war. Coming hot on the heels of Royalist defeats such as the surrender of Dartmouth and the Battle of Torrington, it may have been the moment when the king's position officially became hopeless. Less than a month later Charles surrendered to the Scottish Presbyterian forces at Newark. They later handed Charles over to Cromwell and he was executed.

Although there was damage within the city walls during the Civil War, the fabric of the centre of Exeter came through relatively intact. The outskirts couldn't claim the same. Small battles and skirmishes at places such as St Thomas, Powderham and Cowley caused widespread devastation, sometimes very deliberately, such as the fact St Thomas' Church was razed to prevent Parliamentarian forces from occupying it.

DID YOU KNOW?

When Charles II took the throne, Exeter was concerned that it may end up out of favour due to having declared for Parliament – and therefore against Charles' father – at the start of the Civil War. To try to make amends they bought expensive gifts for the Exeter-born Henrietta Anne and her mother, as well as spending a then gargantuan £600 on a lavishly decorated and jewelled silver gilt salt cellar for the king. Charles certainly liked his gift, as it was soon being used to hold salt and spices during state occasions. It came to be seen as a symbol of the monarch themselves. The Exeter Salt, also known as the State Salt, is now an official part of the Crown Jewels.

The city of Exeter bought the 'Exeter Salt' to curry favour with Charles II following the Restoration. It is now part of the Crown Jewels.

Putting the 'Glorious' in a Revolution

One of the most important acts of 'war' in Exeter was actually completely bloodless and helped ensure a revolution was 'glorious' rather than violent. From the moment Henrietta Anne Stuart's brother James II took the throne in 1685, there were problems. By 1688 he had fallen so far out of favour with the Church of England (James was a Roman Catholic) and much of the aristocracy, that a group of seven Protestant nobles officially requested that the Dutch Prince William of Orange should come to England and take the throne.

James thought that his army would be more than enough to see off this pretender, but he massively underestimated William's diplomatic skills, as well as his own unpopularity. 60,000 copies of William's 'Declaration of the Hague' were distributed, which essentially accused James of betraying his own people, and said that William wished only for peace and to 'preserve and maintain the established Laws, Liberties and customs, and, above all, the Religion and Worship of God, that is established among them'. This and other diplomatic manoeuvres convinced many that William was everything James wasn't.

By the time William landed at Brixham in November 1688, large parts of James' army (and even his own daughter) were poised to abandon their support for the struggling king. The Dutch prince immediately came to Exeter, which was essentially the first city to 'fall' to him after the local magistrates fled. The carefully stage-managed entrance of William into the city, riding on a white horse and accompanied by 200 black men, was again part of his propaganda efforts, as was the care he took to ensure that his troops

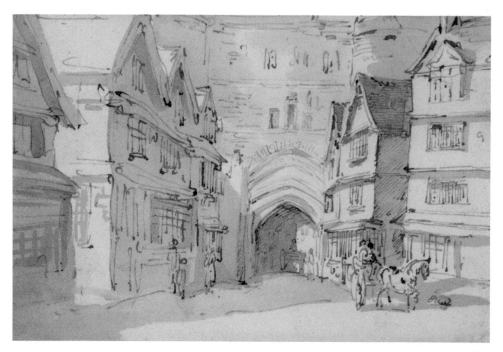

Thomas Rowlandson's 1795 sketch of Exeter's South Gate shows what the main entrance to the city would have looked like around the time William of Orange arrived in the city.

could not be accused of plundering or abusing the locals. He proceeded to underline his different approach by going to the cathedral, where he sat on the bishop's throne and had his declaration of peaceful intent read out before God.

Although it took another couple of months before James' support completely evaporated and William and his wife Mary were declared joint monarchs, the civility with which William arrived in England helped ensure that James soon had no real army to fight with. Although the 'Glorious Revolution' wasn't completely bloodless, without Exeter it may have been far more violent.

The Second World War: A City Devastated

The events of April and May 1942 were so profound in Exeter that it's difficult to know where to start. An entire book of Exeter secrets could be written just about the people and buildings lost when the German Luftwaffe targeted the city. Until then Exeter was considered one of Britain's greatest medieval survivals.

There were nineteen raids in total, with by far the worst occurring on 4 May 1942. 265 people were killed and around 800 more were injured. Around three quarters of the city's buildings had at least some damage, and 1,500 were completely destroyed. Much of the devastation wasn't caused by the bombs themselves, but by the fires that raged afterwards. Particularly after the 4 May raid, the limited firefighting resources couldn't hope to control all the fires, and rescue efforts became more about figuring out what to save and what to allow to burn.

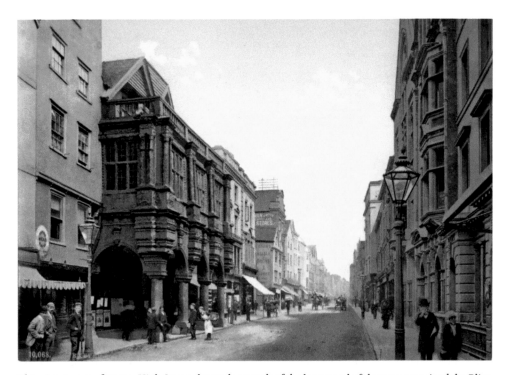

This 1895 image of Exeter High Street shows that much of the lower end of the street survived the Blitz.

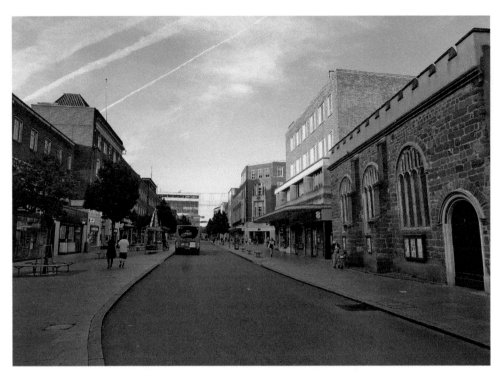

St Stephen's (far right) is the most northerly building on the High Street to have made it through the Second World War. This entire area was bombed and/or burned out during the war and had to be rebuilt.

Exeter was the first of the Baedecker Blitz, where Hitler deliberately targeted England's most beautiful but strategically unimportant towns in retaliation for the bombing of the German cathedral city of Lubeck. 'Baedeckers' were popular tourist guidebooks that Hitler was said to have used to decide where to target. It's not known whether he really did use these books or not, but similar raids were also launched on the likes of Bath, Norwich and York.

The idea that Exeter was strategically totally unimportant also needs a little more unpacking. While largely true, being so close to the likes of Plymouth and Dartmouth put it on the supply lines, with the railways in particular being used to bring provisions through Exeter and on to the nearby naval bases, so the city did have some strategic importance. That is not to suggest this is why Exeter was targeted though. It is also usually said that the city was completely undefended. This is largely true, but does overlook the contribution of a group of Polish airmen who attempted to defend the city. Their contribution may have been deliberately ignored at the time so the Brits could play up how dastardly the Germans were targeting poor, defenceless little Exeter (they have recently been honoured with a memorial plaque in St James' Chapel in Exeter Cathedral).

It's also true that the city had long known bombing was a possibility. As with most other British cities, Exeter had been preparing for years. A blast shield had been built around parts of the Guildhall to protect it in 1940, while many of the most precious objects in the cathedral, including the bishop's throne, had been dismantled and stored elsewhere.

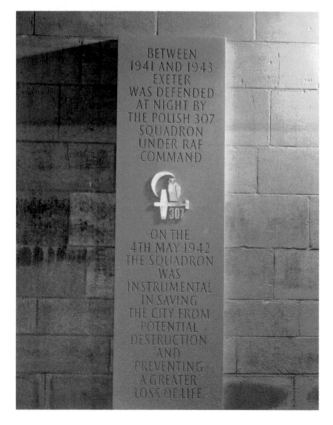

Above: Large swathes of Sidwell Street were devastated during the Second World War. Two-thirds of the street was destroyed including the historic St Sidwell's Church.

Left: It is only recently that the contribution of a squadron of Polish airmen who protected Exeter during the Blitz has been remembered and commemorated.

There is also the famed German radio report of May 1942 where an announcer is supposed to have said, 'Exeter is the jewel of the west; we have destroyed that jewel, and we will return to finish the job.' While it may be a well-known part of the story of the Exeter Blitz, there are many who think it is purely a legend.

What is undoubtedly true, though, is the devastation that the Luftwaffe caused. Everything from the remarkable Elizabethan mansion Bampfylde House to the grand Georgian surroundings of Bedford Circus was bombed or gutted by fire. However, perhaps the greatest secret of the Exeter Blitz is that while it tends to get the sole blame for the city no longer being largely medieval, it was actually the city council that removed or permitted the demolition of more ancient buildings in Exeter across the twentieth century than the Nazis did (and that's ignoring those damaged by the raids that could arguably have been saved, but perhaps understandably at the time they decided to demolish). Mainly to allow better traffic management, the council permitted the destruction of everything from thirteenth-century coaching inns to medieval merchant's houses and to Middle Ages churches. As the great Devon historian W. G. Hoskins noted, in the decades following the Baedecker raids, the city council 'nearly finished the job off' that the Nazis began.

DID YOU KNOW?
Many of the chips and cracks in the steps of the Odeon Cinema on Sidwell Street aren't purely from the decades of wear and tear since it was built in 1937. During the Nazi air raid of 4 May 1942, a bomb landed on Sidwell Street across the road from the Odeon. Some of the shrapnel damage the cinema sustained is still visible on its front steps. Another of the Odeon's secrets that many people don't realise is that while it now has four screens, it was originally one large auditorium seating over 1,900 people. The current largest screen, screen one, is actually just the balcony (and a small extension) of the old auditorium, while screens two, three and four are partitioned versions of what used to be the downstairs stalls.

6. Hidden in Exeter

Following the Blitz and other redevelopments throughout the twentieth century, Exeter may no longer be the jewel of medieval preservation many once considered it, but it still contains an array of fascinating buildings. Not all are as they appear, though, while others are unknown even to many long-time residents of the city. This chapter delves into some hidden buildings that are worth seeking out, as well as those that contain unexpected surprises.

No. 53 and No. 229 High Street

These buildings are two of the most familiar sights on the High Street. Both No. 53 (currently Santander) and No. 229 (currently Urban Outfitters) are attractive black-and-white timber-framed Tudor buildings. Except that they are nothing of the sort.

No. 53 was actually completed in 1905, making it a fairly late example of the Victorian Tudor revival. No. 228 meanwhile is even later, dating from the 1930s.

While No. 53 isn't what it might first appear to be, it does contain some interesting links to Exeter history. The most notable of these is the small statue of Exeter's first bishop, Leofric, in a niche on the second floor, who stands holding a model of the Norman cathedral. He harks back to an earlier time when it was fairly common for religious figures to be carved into buildings – most famously in Exeter, a model of St Peter (now in the Royal Albert Memorial Museum) hung above the corner of High Street and North Street for hundreds of years.

No. 229 isn't completely fake but even what's real is from elsewhere. The first-floor bay windows are genuine 1600s survivals, but come from a building that was demolished in the 1930s on North Street. Perhaps most bizarrely if you want to see what much of the original Jacobean building that once stood on the site looked like, you have to go to the US. Even at the time it was demolished, architectural salvagers realised the value of the myriad original details that the building contained, and so six rooms were stripped of everything from their ceilings to their panelling.

Many of these rooms were bought as complete 'sets' (with US newspaper magnate William Randolph Hearst's foundation buying several) and shipped to America. Rooms from the original No. 229 High Street can still be seen at the Nelson-Atkins Museum in Kansas City and the Detroit Institute of Art. A third room, which was once in San Francisco, has since been brought back and pieces from it are on display in the Tudor Room at St Nicholas' Priory.

Many of the other buildings on the lower High Street aren't quite what they appear either, with some having comparatively recent-looking façades, but interiors that are much older. Others are the other way around, such as two much-admired timber-framed buildings at Nos 225 and 227 High Street (next to Tesco), which retain their original Tudor façades but are largely much newer behind that.

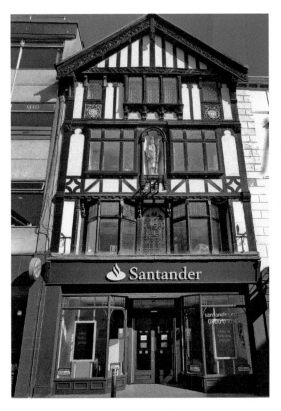

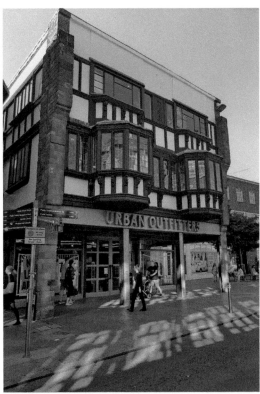

Above left: No. 53 High Street may look Tudor, but it was actually completed in 1905.

Above right: No. 229 High Street contains original Jacobean windows from a building on North Street, but was otherwise built in the 1930s.

Right: The genuine and beautiful historic façade of No. 227 High Street hides the fact that most of the building behind was constructed far later.

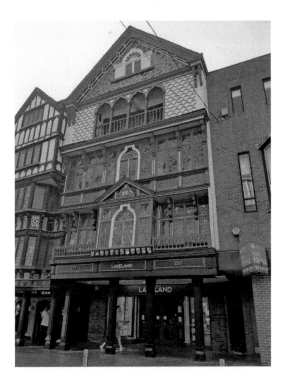

The fifteenth-century Bowhill House in the St Thomas area of the city retains many of its original medieval features.

Bowhill House

Now surrounded by later developments, partway up Dunsford Hill in the St Thomas area of the city sits Bowhill House. It looks a bit like an old farmhouse, but its bulk shows that it is actually something a little grander and older. Richard Holland, MP for Devon, started building the house back in 1422, creating for himself a small mansion based around a quadrangle. The building retains many original features, not least its great hall with a barrel-vaulted wooden roof dating from the late fifteenth century. The old kitchen also still has its original open fire and oven.

Impressively, Bowhill passed down through the same family until the 1930s. It was later bought by the government, who spent twenty years documenting and preserving every inch of it. English Heritage still hold the freehold on the Grade I-listed property.

Those who do know Bowhill sometimes claim this was once the site of Exeter's first lunatic asylum. However, this was actually a little further down the hill, closer to where Bowhill Primary School now stands.

St Katherine's Priory

Many visitors to Exeter's Morrisons supermarket have absolutely no idea that just a few feet away behind the trees at the rear of the building are parts of a Middle Ages priory. St Katherine's was one of only three priories founded by nuns in Devon. It was set up in the late twelfth century, but the surviving building – which once made up

much of the north range – dates from the early to mid-1300s. The priory was closed during the Reformation, after which many of the original buildings were torn down. In the early twentieth century what remained was almost demolished before a concerted effort was made to preserve and document it, leading to it being listed as an ancient monument in 1938.

The nunnery of St Katherine may have been disbanded more than 450 years ago, but their presence still echoes in this part of the city. The Mincinglake stream and park are believed to be named after them (similar to the way the city of Munchen/Munich in Germany means 'by the monks', but anglicised and feminised over the years into 'Mincing'), while the remains of the dam they built to create a fishing lake are still traceable by those who know what they're looking for.

Cricklepit Mill

Now the headquarters of the Devon Wildlife Trust, the recently preserved and restored Cricklepit Mill is a fascinating time capsule of Exeter's past. It's believed a mill has operated on the site since the late twelfth century, with the current buildings dating from the 1520s onwards. With its waterwheel still present it's one of the most prominent reminders of how milling once helped drive the city. As well as grinding corn from its earliest days, when Exeter became a textile centre Cricklepit also started fulling wool.

While the current buildings at Cricklepit Mill date from the 1520s onwards, a mill has been on the site since the twelfth century.

The leat that ran through it was just part of a complicated water management system that drove numerous mills along the Exe. These didn't only produce flour and wool, but also everything from rubble to manganese. There was also a thriving paper industry along the waterfront until the nineteenth century. The Mill on the Exe pub was once one of these paper mills, while the preserved ruins of another can be seen around a mile downstream from the quay.

Exeter Synagogue

If you ask most people about Exeter Synagogue, the response is likely to be 'Is there one?' However, there is and it's quite an important one. Tucked away on a side street by the Mary Arches car park, Exeter Synagogue is one of the three oldest synagogues in continuous use in the UK (the only older ones are in London and Plymouth).

After an absence of hundreds of years following Edward I's expulsion of the Jews from England in 1290, a small Jewish community began building in Exeter in the eighteenth century, which was large enough by 1757 to lease its own burial ground. This Jewish cemetery still exists off Magdalen Road, just next to Bull Meadow Park.

Just a few years later, the community felt it was established enough to want its own permanent place of worship, and so land close to St Mary Arches Church was leased (through an intermediary as even at that time there were massive restrictions on Jews owning or leasing land) and a synagogue built. While it has been altered over the years, first being expanded as the Jewish community flourished in the early nineteenth century

The low-key façade of Exeter Synagogue hides the fact that it is one of the longest continuously operating Jewish places of worship in the UK.

before almost closing as it diminished later in the 1800s, the building has survived and still holds regular ceremonies.

The shrinking of the Jewish community in Exeter in the later nineteenth century reflected what was happening to the city at the time. Many of the Jewish families were originally merchants from the Netherlands and Germany who had been brought to the city by its trade with those countries. As that trade left the city, so did many of the people once supported by it.

Royal Clarence Hotel

The Royal Clarence Hotel on Cathedral Green certainly can't be classed as a 'secret', especially after it made national headlines in October 2016 when it burned to the ground alongside two neighbouring historic buildings (as well as parts of the back of properties on the High Street). However, its history still holds secrets.

It is perhaps most famous as the 'oldest hotel in England'. The problem with that is that at best it was the first place to refer to itself as a 'hotel', and it may not have even been that. In 1770 it was advertised as the 'New Coffee-house, Inn, and Tavern, Or, The Hotel, In St. Peter's Church-yard, Exeter,' which has been claimed means it was the first English place to call itself by the French word 'hotel'. However, it certainly wasn't the oldest place continually offering accommodation and there are some contested older uses of the word 'hotel' in reference to other places.

The burned-out shell of the Royal Clarence Hotel during its reconstruction. The original façade will be rebuilt, while modernising the interior.

What is certainly rarely mentioned is its past as a hangout for members of the British Union of Fascists in the 1930s (nor does the nearby Guildhall Shopping Centre do much boasting about how the Civic Hall that used to sit on the Higher Market part of the site once held a particularly anti-Semitic speech by Sir Oswald Mosley). The Royal Clarence certainly had some better visitors than these over the years, though, including Beatrix Potter, Thomas Hardy and Clark Gable. The composer and musician Franz Liszt also gave two recitals there in 1840.

Mol's Coffee House

Mol's Coffee House on the Cathedral Green is such a perfect 'olde worlde' building – with its timber framing, royal coat of arms above the door, ornate gabling and wooden balustrade – that it almost wouldn't be shocking to discover it had been built by Disney. However, it is a genuine Tudor survival (although the gabling and third storey are nineteenth century). It's just its history that's a work of fiction.

It's often said it was one of the first coffee houses in England, opened by an Italian called Thomas Mol in the Elizabethan era. There the great sea captains of the age, such as Sir Francis Drake, Richard Grenville, John Hawkins and Sir Walter Raleigh, met to discuss

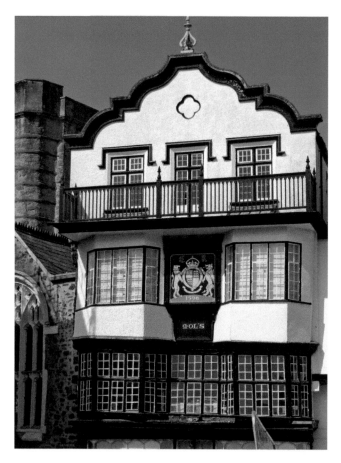

The picture-perfect Mol's Coffee House is a genuine Tudor building, but was never the hangout for Sir Francis Drake as legend says it was.

important events such as the impending arrival of the Spanish Armada. However, this history appears to have been made up out of whole cloth.

In reality, during much of the Elizabethan period it was leased by a man called John Dyer, and by the end of the sixteenth century it was partly being used as a custom house, not a coffee house. It probably didn't become Mol's and start serving coffee until 1726 when it was leased by Mary (shortened to Mol) Wildy. It's thought a picture framer called Thomas Worth made up most of the building's supposed past in the late nineteenth century in order to promote his business (although the idea of an Italian called Thomas Mol running a coffee house in Exeter may predate him).

Likewise, the legend that the nearby Ship Inn on St Martins' Lane was Sir Francis Drake's favourite drinking hole was also probably made up by Worth, as was the apocryphal Drake quote still painted next to the pubs' door: 'Next to my own ship I do most love that old Ship in Exon, a tavern in Fish Street, as the people call it, or as the clergy will have it, St. Martin's Lane'.

The Well House Tavern
While its frontage survived, the sixteenth-century Well House Tavern was also devasted by the fire that destroyed the Royal Clarence Hotel. However, its most interesting feature, its cellar, survived. The largely Norman cellar also contains what's thought to be a Roman bath, as well as the eleventh century St Martins Well that gives the tavern its name. Most infamously, the cellar contains a skeleton in a display case in an alcove.

The legends regarding these bones are numerous including claims that it is a victim of the Black Death or a witch. Perhaps the best-known story is that they are parts of a star-crossed fourteenth-century monk and nun (sometimes a priest and his illicit girlfriend) who fell in love and then threw themselves down the well so they could be together through eternity. Some historians have even suggested they may belong to an Anglo-Saxon. However, others believe that, as with Sir Francis Drake's love of the Ship Inn around the corner and Thomas Mol and his Elizabethan coffee house diagonally opposite, the bones were placed into the cellar at some point in the past as a tourist attraction.

Medieval Exe Bridge
It is remarkable how the Exe Bridges roundabout (technically a gyratory) carries thousands of people across the river each day, but how few notice – or at least pay attention to – the remains of the medieval bridge next to it. It is an incredibly rare survival, largely because the crossing points of rivers tend to stay in the same place, with the bridges inevitably being changed and updated (or destroyed by war or flood) and the old ones completely removed. Exeter's had a slightly different history, as it essentially got buried and forgotten.

When Exeter first got a stone bridge in the twelfth or thirteenth century, it needed to be a massively long 750 feet (230 metres) in order to not just cross the river but also to ford a large marshy area. However, as drainage and water management was gradually brought in and increasing amounts of land reclaimed, the city end of the bridge became more street than bridge and no longer crossed the river. Buildings had crowded this end

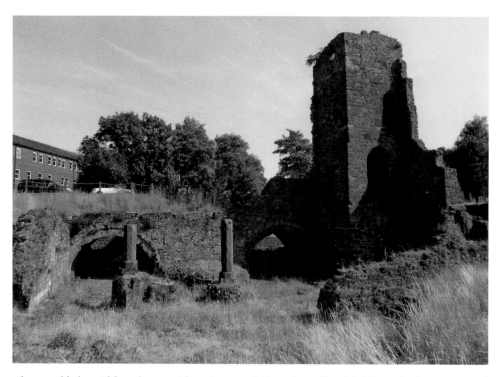

Above and below: Although an accidental survival, Exeter's medieval bridge is the best-preserved substantial remains of an early stone bridge in the UK.

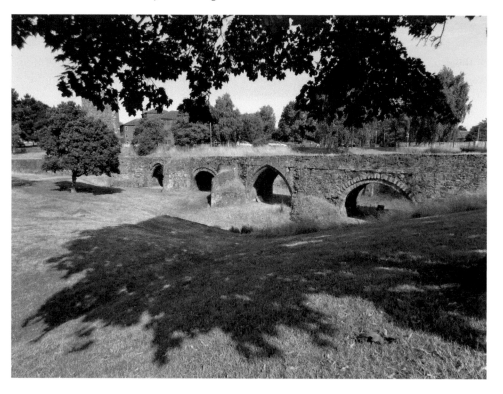

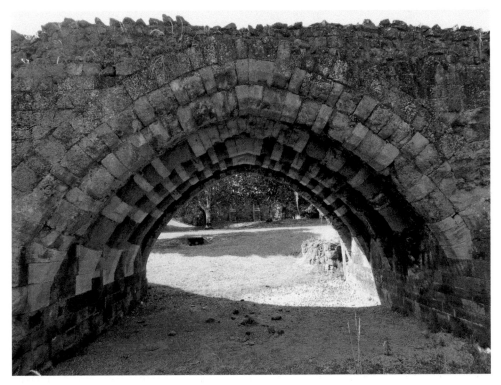

Some of the medieval bridge's arches still retain evidence of original thirteenth-century workmanship

of the bridge since its early days so that when a new river crossing was built in the 1770s on a different axis, this part of the old bridge just became Edmund Street (the rest of the bridge was completely demolished).

Over the years many people forgot there even was a bridge underneath as the multistorey buildings and later street surfaces completely obscured the road's origins, particularly from the front. It became even less apparent through the Victorian age, when the ancient timber-framed buildings whose backs hung out over the bridge's arches were demolished and the road widened. New buildings were built along the street until only St Edmund's Chapel hinted at its much older past.

As a result, when a new inner bypass was planned in the 1960s that would destroy Edmund Street, it was impossible to tell what, if anything, of the original structure remained. Many suspected any medieval remains would have been rubbed out in the Victorian era, but as the contractors began to dig, they discovered that eight of the bridge's arches remained, almost intact, under the soil. Many of them still showed signs of thirteenth-century workmanship. By that point it was too late to save St Edmund's Chapel (except for its still-standing tower), but the bridge itself was excavated and now sits fully exposed for the first time in hundreds of years.

It may have been only the third large stone-built bridge in England and it's certainly the oldest surviving substantial remains of any such bridge in the UK.

The medieval Exe Bridge was only uncovered during the flattening of this part of the city for a 1960s traffic management scheme.

Tudor House

Just down the road from the medieval Exe Bridge is the Tudor House on Tudor Street. As the street name suggests, at one point there were numerous medieval buildings crowding this bit of the city, but Tudor House, originally built in the late sixteenth or seventeenth century, is one of the few to remain.

This truly beautiful house looks like it must have remained the same since the moment it was built, but the truth is that by the 1960s it was in a dilapidated state, being used as an electrical repair shop and at severe risk of being demolished. Thankfully, though, it was purchased by Bill Lovell, who spent the next decade – and a vast amount of money – restoring it. He almost bankrupted himself in the process, but ensured the city retained one of its jewels.

Although used for a time as a restaurant, it is now once more a private house.

The House That Moved

It is one of the more famous stories of Exeter, but it seems wrong not to mention the House That Moved, even if it's not much of a secret! During the clearance for the aforementioned new road system in 1961, the Merchant's House on the corner of Edmund Street and Frog Street was due to be demolished. However, being one of the oldest buildings in Exeter (thought to date from the 1430s) a concerted effort was made by some to have it listed and saved. The efforts worked and a stay of demolition was put on it. The problem with that was that if left where it was, the house could have derailed the entire project.

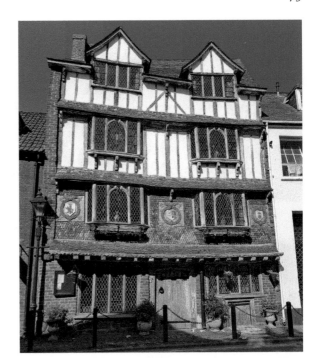

The current picturesque perfection of Tudor House belies the fact that in the 1960s it was dilapidated and in serious danger of being demolished.

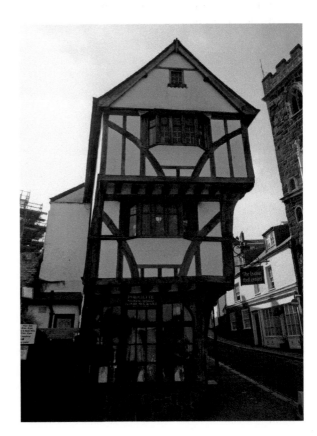

The ancient House That Moved made worldwide headlines in 1961 when it was lifted from its original foundation and moved 90 metres to get it out of the way of a new road scheme.

To get around it, Exeter City Council came up with a plan that made worldwide news. The house was jacked up, shifted onto rails and gingerly moved 90 metres up the hill to a new position opposite St Mary Steps Church. The whole process took four days, with most of the actual 'move' taking place on 13 December 1961 – watched by journalists, camera crews and interested spectators. Despite the risks, it worked and the building was successfully anchored into its new home.

Stepcote Hill

Opposite the House That Moved and next to St Mary Steps Church is another of Exeter's oft-overlooked treasures – Stepcote Hill. Due to its steepness and the fact the construction of New Bridge Street in the eighteenth century moved traffic entering from the west of city a few hundred feet away, the road surface has never been modernised and so it still retains its ancient cobbles and steps.

Unfortunately, numerous important timber-framed merchants' houses were completely demolished on the hill during the city's zeal for slum clearance from the 1930s onwards, where rather than improving the existing housing stock all the residents were moved elsewhere and the buildings flattened. Some rather dull, utilitarian interwar houses were then built in their place. The result is that Stepcote is only truly picturesque on its lower reaches, but it does give a very rare insight into what the city must have looked like before it was smothered in tarmac. The cobbles are considered important enough that they are listed in their own right.

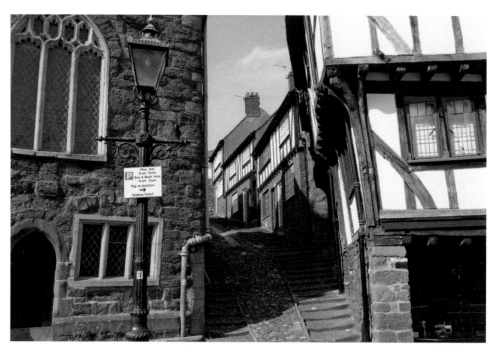

The ancient cobbles of Stepcote Hill give an insight into what Exeter was like before modern road surfaces.

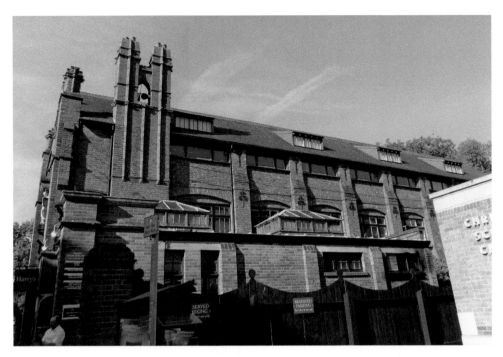

'Harry's Restaurant' was originally the workshop of the prolific Harry Hems, who worked on thousands of churches, statues and memorials.

No. 84 Longbrook Street, aka Harry Hems' Workshop

No. 84 Longbrook Street is better known to most Exeter residents as 'Harry's Restaurant', but while they may have noticed that it's a striking building, they may not know what it was, or realised that 'Harry' isn't a chef. The Harry in question is Harry Hems, a woodworker and sculptor who arrived in Exeter in 1866 virtually penniless following a ruinous trip to Italy. He was hoping that the job he'd got creating sculpture for the outside of the new Royal Albert Memorial Museum would help him out of a hole. Legend has it that when he got off the train in the city, he almost immediately found a horseshoe, which he saw as a sign of good luck.

The job at the museum helped him get established in the city, and soon he had more work than he could handle, creating wood and stonework for hundreds of churches and other buildings. In 1881, he decided he needed his own workshop, and that it should be built in a style that showed off what he could do, with Gothic detailing and stained glass. The result is the building at No. 84 Longbrook Street. At its height, Hems' company wasn't just working from that 2-acre site, as he also had over 100 staff in London, Ireland and Oxford. His most important commissions included restoring the medieval screen at St Albans' Abbey, as well as building another screen in a similar style for Christ Church Cathedral in St Louis, Missouri. His work that you can see around Exeter includes the Martyrs Memorial pictured earlier in this book.

The business closed in 1938, but the building is still known as the Harry Hems Centre. Its creator's lucky horseshoe is still hung over the door.

Harry Hems' lucky horseshoe, found just after he arrived in Exeter, still hangs above the door of his former workshop.

DID YOU KNOW?

Just off Bartholomew Street, Exeter has its own catacombs, which were built in the 1830s as the 'elite' part of a larger burial ground. The cemetery was the first ever built with public funds, and the façade of the catacombs were the first funerary buildings in the UK built in an Egyptian style. However, not only did they prove incredibly difficult to construct (at one point the foundations completely failed), but they were never that successful. Although built with a capacity for 1,400 coffins in individual brick vaults, the majority of the 'loculi' were never filled. This rather creepily means that the catacombs still figure in the city's disaster planning. If things ever go so badly wrong that crematoria, cemeteries and mortuaries can't keep up with the demand, the catacombs will become a place to temporarily store dead bodies.

The Guildhall

Exeter's Guildhall is another of the city's buildings that's become so familiar as to appear to be almost invisible. However, it is one of its most important, not least because it's believed to be oldest building in the UK to have been in continuous civic use – well, probably.

Although this idea is often touted as absolute fact, there is some dispute. The current building is known to date to at least the fourteenth century and some of it appears to be twelfth century. There is also evidence of a guild in Exeter by the start of the eleven century, which may have had its hall on the same site; if true, the claim to be the longest in continuous civic use is almost certainly true. It should be noted though that while much of the structure is fourteenth century, the frontage (or portico) that juts out over the High Street is Elizabethan.

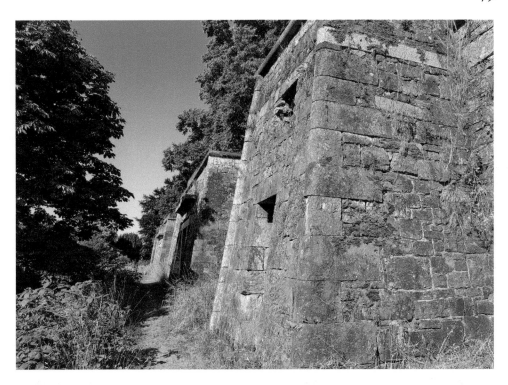

Above: Exeter's Victorian catacombs still feature in the city's disaster planning as a mortuary of last resort.

Right: The Guildhall is mostly fourteenth century, but the iconic portico jutting out over the High Street was added in the Elizabethan era.

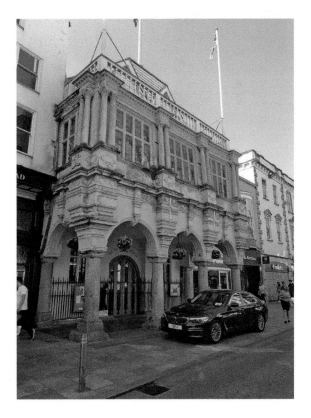

Above left: The sturdy and secure back of the Guildhall hints at the fact that it was once a court and that behind the windows were prison cells.

Above right: This student accommodation block was once the site of the worst theatre fire in British history.

Perhaps one of its bigger secrets is hinted at on the rear of the building (within the Guildhall Shopping Centre), which many people have noted looks more like a medieval prison than anything else. For many hundreds of years, as well as fulfilling a role as a meeting place for the city's civic leaders, it was a court.

That included it holding one of the so-called Bloody Assizes of 1685, where Judge George Jeffries toured the south of England from Winchester to Exeter, overseeing the trials of those accused of treason for their part in the Duke of Monmouth's attempt to overthrow James II. Quite how brutal Jeffries was – with hundreds of people hung, drawn and quartered, and then those quarters hung from trees – was one of the things that turned public opinion against James II and led to the arrival of William of Orange in 1688, which as we've already seen, Exeter also played its part in.

The building still contains hints of its judicial past, such as a fourteenth-century cellar towards the front of the building that was once known as the 'pytt' and used as a prison. Four cells still remain towards the rear of the building, which are now largely used for storage. It was last used as a court in 1971.

Theatre Royal

The modern office and student accommodation building on the corner of Longbrook Street and New North Road contains few hints that it was once the site of one of the great

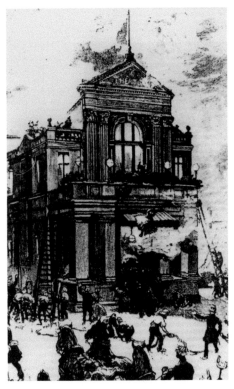 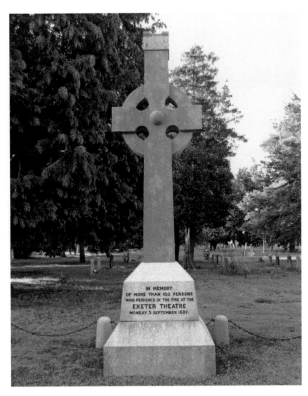

Above left: On 5 September 1887, Exeter's Theatre Royal caught fire killing 186 people. The disaster was instrumental in changing the law surrounding safety in public buildings.

Above right: A memorial marks the spot in Higher Cemetery, Heavitree, of a mass grave for victims of the Exeter Theatre Royal fire.

disasters of the Victorian age, and what is believed to have been the deadliest theatre fire in British history.

Two theatres built close to Southernhay had already burned down in Exeter in 1820 and 1885, when a replacement for the second of those was hastily thrown up at the top of Longbrook Street. The new Theatre Royal had a capacity of around 1,500 and opened in 1886. On 5 September 1887, a new melodrama by Wilson Barrett called Romany Rye was opening. An audience of around 800 people were in attendance when a naked flame lit some gauze at the edge of the stage. The fire started spreading almost immediately, causing immense panic.

While nearly everyone in the stalls escaped, the exit from the upstairs gallery proved woefully incapable of handling the panicked exodus. People were crushed to death in the rush to get out, making the exits impassable. Others trapped behind them then succumbed to the fire and smoke. In total 186 people died. There were so many victims that most had to be buried in a mass grave in Higher Cemetery, Heavitree. A Harry Hems-designed memorial still marks the burial spot.

National outrage at the disaster was instrumental in getting the laws changed regarding safety in public buildings. When the Theatre Royal was rebuilt, it was lit with electric lights (rather than gas) and had a fireproof safety curtain.

7. Famous Exeter

Exeter has certainly produced more than its fair share of distinguished names over the last 2,000 years. These are just a small number of the many famous names who were either born in Exeter or who have some form of Exeter connection:

Richard Hooker (c. 1554–1600): Great Theologian

Thanks to his familiar statue, which sees him permanently seated on Cathedral Green, often with a visiting seagull perched on his head, Richard Hooker is a very familiar figure to many Exeter residents and tourists alike. But who was this scholarly Tudor figure?

Hooker was one of the leading theologians of the sixteenth century. In a century riven by religious discord as the Reformation divided Christianity into Catholicism and the new Protestantism, this was no small achievement as there was certainly a lot of debate going on about religion at this time. Although born to relatively lowly origins in Heavitree, Hooker grew to be a distinguished scholar and a master of the Temple Church in London. His fame rests on his authorship of his masterpiece, the Laws of Ecclesiastical Policy (1597), which was left unfinished at the time of his death.

A rare image of the statue of Richard Hooker on Exeter Cathedral Green without a seagull perched on his head.

His theological position is complicated and is still hotly debated by scholars to this day. Essentially, Hooker seems to have been defending the fledgling Church of England from attacks from more radical factions on the Protestant side such as Puritans. However, after Hooker's death, many of his arguments were in fact taken up by the very Puritans who in life he had been keen to admonish.

Nicholas Hilliard (c. 1547–1619): Elizabethan Artist

Born to a local Tudor goldsmith in Exeter, Hilliard would, in due course, become world renowned, his name becoming synonymous with the miniature portraits which he was so adept at producing. His early years, however, were clouded by the religious turmoil of the sixteenth century. As committed Protestants, his family were forced to flee the country following the accession of the staunchly Catholic 'Bloody' Mary to the throne in 1553. The Hilliards returned to England when Elizabeth I became Queen in 1558, but his early years in France undoubtedly had an enduring influence on the young Nicholas.

In his twenties, he was appointed as goldsmith and painter to the Queen and produced portraits of both her, Mary Queen of Scots and later King James I of England (who was also James VI of Scotland). Hilliard retained close ties to the city of his birth throughout his life, inheriting property there from his father. Despite this and the considerable success and fame he enjoyed from his work, he suffered continual financial problems throughout his life.

DID YOU KNOW?
The founders of the legendary Barings Bank, John and Francis Baring, were both born in Exeter.

General Sir Redvers Henry Buller (1839–1908): Hero of the Zulu Wars

As with Richard Hooker, Buller is perhaps better known in Exeter today for being a statue than he was for being a man. This was certainly not true during his lifetime, however, when Buller was famed first as a hero, then as a source of scandal, then, finally, towards the end of his life, as a hero once again.

He wasn't actually born in Exeter at all but to the immense wealth of the Downes Estate in nearby Crediton. Buller's father, James Wentworth Buller, was an MP for Exeter while his mother Charlotte Howard Buller was a daughter of the aristocratic Howard family. After attending Eton, Redvers embarked upon the military life, serving with distinction in the Second Opium War and the Ashanti campaign (in which he was slightly wounded) and helping to put down the Red River rebellion in Canada in 1870.

It was the Zulu Wars in 1879 that brought Buller true fame and a Victoria Cross. During an eventful day during the hasty retreat from Inhlobana, Buller took the time to rescue three British officers in three separate incidents, each occurring while he and the British were under hot pursuit by the Zulu forces. Buller undeniably saved lives that day while showing scant regard for his own personal safety.

The equestrian statue of General Sir Redvers Buller is an Exeter landmark, but became a site of tragedy in 2017 when a young man died after falling from it.

His reputation suffered in later life when he was forced to resign from the army as punishment for failures during the Second Boer War (1899–1902). It was true that he had served as a general during the disastrous battles at Coleno and Spion Kop and was partially responsible. However, it seems likely Buller was to some extent scapegoated for the failures of others. Happily, the people never forgot his earlier heroism. The statue created by Adrian Jones stands near Exeter St Davids station on the junction of New North Road and Hele Road, en route to Buller's old home in Crediton. It was unveiled in 1905, a few years before the old general died. Not long after his death the fashion for building monuments to war heroes began to decline. To get such a statue erected during his own lifetime was a rare honour for Redvers.

Fred Karno (1866–1941): Music Hall Legend

The world of show business would not be what it is today without the influence of Fred Karno, who was born in Paul Street, Exeter. Though his family was to leave Exeter for Nottingham when he was nine years old, Karno – who was born Frederick John Westcott – retained a lifelong sense of pride over his Devon origins.

As a music hall actor, it is Karno who is widely credited with popularising the custard pie in the face gag generally associated with clowns today. It was at the business end, however, where Karno, a shameless self-promoter, was to truly excel. His most enduring

legacy was to launch the careers of two legendary performing talents: Arthur Jefferson (later Stan Laurel of Laurel and Hardy fame) and Charlie Chaplin. Ironically, the subsequent success of these two in the new emerging medium of cinema undoubtedly contributed to the death of the music hall world in which Karno himself thrived. He was declared bankrupt in 1926, but he was never forgotten.

Legendary silent film producer Hal Roach declared, 'Fred Karno is not only a genius, he is the man who originated slapstick comedy. We in Hollywood owe much to him.'

Violet Vanbrugh (1867–1942) and Irene Vanbrugh (1872–1949): Acting Sisters

The daughters of a Heavitree vicar, the Vanbrugh sisters enjoyed long acting careers that spanned the period from the late Victorian era to the busy cinema years of the Second World War. The girls attended Exeter High School and were originally named Barnes, before adopting their more glamourous stage surname.

Younger sister Irene was the more successful of the two, appearing in the premieres of plays by JM Barrie and Oscar Wilde, as well as performing before George V and the future Queen Mother. She became a dame and in her final years enjoyed a successful career in films, including *The Rise of Catherine the Great* (1938) and *I Live in Grosvenor Square* (1945) with Rex Harrison. Violet enjoyed many years of success too, particularly in Shakespearian roles. In later life she shined in the Oscar-winning film version of *Pygmalion* (1938).

Tommy Cooper (1921–84): Comedian and Magician

'My doctor said to me: I want you to drink a bottle of wine after a hot bath. I couldn't even finish drinking the hot bath! ... I bought some pork chops and asked the butcher to make them lean. He said: which way? ... I sleep like a baby. I wake up screaming every morning at 3 am.' These are just some of the many jokes delivered by the legendary comic

A blue plaque was placed in Princesshay to commemorate the acting sisters Violet and Irene Vanbrugh, both of whom were born and raised in Exeter.

Tommy Cooper attended the school on Ladysmith Road, before his family moved to Southampton when he was nine.

Tommy Cooper. Famed for his fez, odd lumbering appearance and magic tricks that deliberately went wrong, Cooper (in reality a very accomplished magician) was, in fact, born in Caerphilly, Wales. However, his mother had been born in Crediton in Devon and the family moved to Exeter when he was just three years old.

He attended Mount Radford School in Ladysmith Road and the family lived at Ford's Road off Willey's Avenue at the back of Haven Banks. At the age of eight, Tommy was given a magic set by an unsuspecting aunt, which ignited a passion within the young man. Sadly, Tommy's father had gambling problems and the family moved to Southampton when Tommy was nine. After service in the Second World War he established himself as one of Britain's biggest comedy names, famed for his widely impersonated catchphrase, 'Just like that!'

Behind the scenes things were not always so happy, however. Cooper was notoriously mean with money and an alcoholic. In 1984, he suffered a fatal heart while performing on live TV. It was a sad end to the life of a comedy legend.

Dracula?

While Bram Stoker's Dracula is a fictional character, he has links to Exeter that have even led some to suggest the vampire almost comes from the city. Exeter is mentioned several times in the 1897 novel as it is where the protagonist, Jonathan Harker, comes from. In the book, Harker is a recently qualified solicitor working at a practice on the Cathedral

Tradition says this building on the Cathedral Green is where Jonathan Harker worked in Bram Stoker's classic, *Dracula*.

Green, who travels off to Transylvania after his employer asks him to help a mysterious client. Tradition says the building Harker worked at is the old City Bank (currently Jack Wills) opposite the west front of the cathedral.

More recently it has been claimed by writer and Dracula fan Andy Struthers that the reason Stoker made the city Harker's home is because he was inspired by Exeter writer Sabine Baring-Gould's book *Lycanthropy: the Study of Werewolves* and his vampire story *Margery of Quether*. Although many agree Baring-Gould helped inspire Stoker, there are disagreements as to how strong an inspiration he was. Either way it gives Exeter an unexpected link to the great novel.

DID YOU KNOW?
While Charles Dickens was not an Exeter native, he spent a lot of time in the city due to his close friendship with Thomas Latimer, editor of the *Western Times*. Dickens met his wife, Catherine, in the city. He also rented a house in Alphington for his parents to live in. That property, Mile End House, now has a plaque to mark its illustrious literary connections.

Modern Exonians

Many famous Exonians are still active today. As the founder and lead singer of Coldplay, Chris Martin can claim to be one of the most successful British performers of the twenty-first century so far. Born in Whitestone, near Exeter, Martin attended Exeter Cathedral School and performed with Coldplay at the Cavern Club on Gandy Street early in his career. His grandfather was a one-time mayor of Exeter while his family founded Martin's Caravan Park near Clyst St George, selling it during the 1990s.

Other famous modern Exonians include Beth Gibbons, lead singer of the band Portishead; Toby Buckland, the presenter of TV's *Gardener's World*; cricketer Trevor Anning; Matthew Goode, star of films such as Watchmen and Brideshead Revisited; Harry and Luke Treadaway, the identical twin actors who've (individually) appeared in movies such as *Attack The Block*, *A Street Cat Named Bob* and *The Lone Ranger*; and the writers Cathie Hartigan and Lucy Banks.

DID YOU KNOW?
The popular Poet Laureate Sir John Betjeman (1906–84) wrote a poem entitled 'Exeter' in the 1930s that refers specifically to Colleton Crescent. Thankfully, it is much kinder about the city than the poet's more famous 'Slough' was about that town.

Famous Students

In addition to those born or raised in Exeter itself, a wealth of talented names have spent time studying at the University of Exeter.

Undoubtedly the most famous former Exeter student is J. K. Rowling. Now world renowned as the author of the Harry Potter books, Rowling studied Greek and Roman Studies at Exeter between 1981 and 1986, having switched from French. She had one witty piece of writing published in the university journal 'Pegasus', an article inspired by her experiences studying Classics entitled, 'What Was The Name of That Nymph Again?'

It is now clear Rowling drew on aspects of her time in Exeter as a source of inspiration for bits of her hugely successful Harry Potter books. While some of the claims to local connections are speculative or open to interpretation – such as Gandy Street inspiring Diagon Alley or various wizarding world pubs being inspired by the likes of the Old Firehouse on New North Road or The Black Horse on Longbrook Street – others are undeniable. The character Dawlish is obviously named after the nearby town, while Ottery St Catchpole, where the wizardly Weasleys live, is both located in Devon in the books, and has a name inspired by the real-life Devon village Ottery St Mary, a few miles outside Exeter.

Author Hazel Harvey has also suggested Hogwarts' tunnels may have been inspired by Exeter's historic Underground Passages and that the clock at Exeter Cathedral with its circling sun and moon may have given Rowling the idea for headmaster Dumbledore's gold watch.

Other notable Exeter alumni include Robert Bolt (1924–95), the playwright and Oscar-winning screenwriter of *A Man For All Seasons*, who studied in the city after the Second World War. Screenwriter Abi Morgan, comedy writer John O'Farrell, TV presenter and journalist Matthew Wright and novelist Santa Montefiore all studied at the university during the 1980s and 1990s. The musicians Thom Yorke, from the band Radiohead, and Will Young were late twentieth-century Exeter students.

Cartoonist Steve Bell and the politicians Andrew Lansley, Sayed Javid and Caroline Lucas, the first ever Green Party MP, are also Exeter graduates. There will undoubtedly be many more famous Exeter people or university alumni in the future.

It has been speculated that due to J. K. Rowling's time in Exeter as a student, Gandy Street inspired Harry Potter's Diagon Alley.

J. K. Rowling has confirmed she frequented the Black Horse on Longbrook Street, but not whether it inspired any Harry Potter pubs, as urban legend suggests.

8. Princesshay: A Quick Case Study

At a first glance the Princesshay Shopping Centre seems the antithesis of anything historical. Opened in 2007 as a mix of high street stores, restaurants and residential flats, it is mostly twenty-first century. However, it is a perfect example of how Exeter is filled to the brim with secrets and hints about its past, even in the most modern of places.

That is evident at the back of the developments' main anchor store, Debenhams, where in a tucked-away corner stands a large metal plaque which reads, 'A Dominican Convent occupied the site of this circus A.D. 1259. In 1539 it was granted to John Lord Russell who converted it into Bedford House, where in 1644 was born Princess Henrietta, daughter of Charles I. In 1773 it was removed and the erection of this present circus commenced.' This gives a potted history of the site the precinct stands on, and also shows that the plaque itself is not new (it was cast in 1897), as it survives from Bedford Circus, a grand double crescent that was considered by some to be among the most beautiful Georgian streets

Above left: The twenty-first-century Princesshay Shopping Centre features a variety of Exeter secrets hiding in plain sight.

Above right: This Victorian plaque behind Debenhams reveals Princesshay's past as the site of a priory, a grand house and a Georgian crescent.

in Britain – some say a rival to Bath's Royal Crescent. However, it was badly damaged in the Blitz and the rest was knocked down at the end of the Second World War. The area's time as Bedford House (Exeter home of the Duke of Bedford) and Bedford Circus is also marked by the fact that the now pedestrianised road running from the High Street to Southernhay is still called Bedford Street.

DID YOU KNOW?
The 'princess' of Princesshay is Princess Elizabeth (later Elizabeth II), who came to Exeter in 1949 to unveil a plaque on a specially built feature on the site where the shopping precinct was going to be built. At the time she arrived no reconstruction had commenced – there were just pegs marking where buildings would later be.

Walking past the plaque onto Roman Walk takes you to the city wall, with evidence of Roman, Anglo-Saxon and medieval stonework on display. Where there's a gap in the wall you can see the city's official memorial to the damage and death sustained during the Luftwaffe raids on Exeter during April and May 1942. Nearby a blue plaque commemorates that Bedford Circus was the birthplace of stage and screen star Violet Vanbrugh.

In Princesshay, the ancient city wall is sandwiched between much more recent developments.

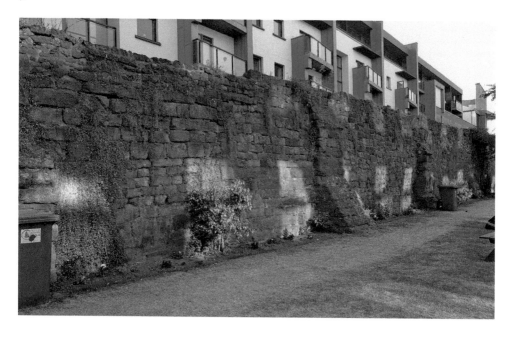

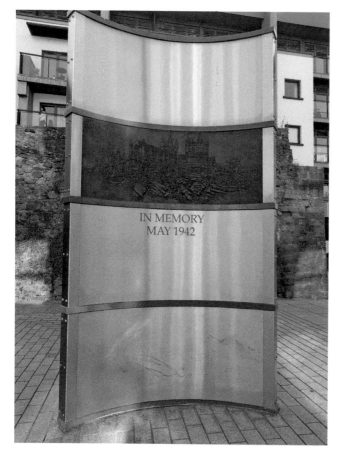

Above: The city wall in Princesshay still shows evidence of Roman craftmanship.

Left: The official memorial to the Exeter Blitz is in an open area just off Roman Walk.

Right: The Blueboy statue is a reminder that for hundreds of years the St John's Hospital School occupied part of the site.

Below: The Exeter Phoenix artwork was relocated from the original Princesshay Shopping Centre to the new one when it was rebuilt between 2004 and 2007.

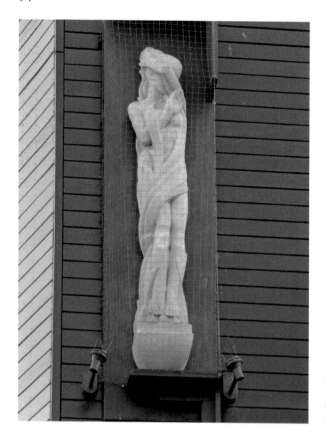

Darsie Rawlins' sculptures *Hope* and *Despair* from the original Princesshay Shopping Centre look over the main arcade of the latest iteration of the site.

In the main shopping arcade stands a small statue known as the Blueboy. It is a reminder that close by on the site was once the St John's Hospital School, a former religious hospital that became a free grammar school following the Reformation. The pupils became known as 'blue boys' because of their uniforms. The statue was one of several cast in 1860 during the redevelopment of the school (and which replaced an eighteenth-century stone Blueboy statue). The school closed in 1931 and its buildings were destroyed during the Blitz, but the statue survived and still has pride of place in the new Princesshay.

Close to the Blueboy statue, on the wall of Topshop, is the Exeter Phoenix, an artwork originally commissioned by the Hughes motor garage of Exeter to symbolise the rebirth of Exeter following the Second World War (Thomas Sharp's original plans for the post-war redevelopment of this part of the city were titled 'Exeter Phoenix'). This along with Darsie Rawlins' sculptures *Hope* and *Despair* part way along the main arcade survive from the earlier post-war incarnation of the Princesshay Shopping Centre. The original Princesshay that was erected on the site in the 1950s was the first pedestrianised shopping street in the UK, but over the years it failed to adapt to changes in retail until by the early twenty-first century it was little used or frequented. Despite some quite vociferous attempts to save it, the first Princesshay was demolished in 2004 and replaced with the new incarnation.

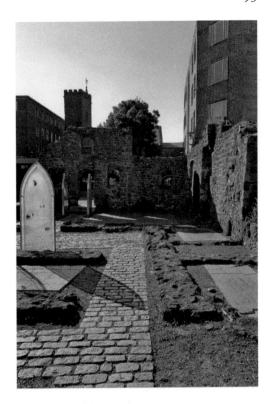

Right and below: The fifteenth-century
St Catherine's Almhouses were bombed
during the Second World War, with the ruins
left as a memorial to the destruction the
city suffered.

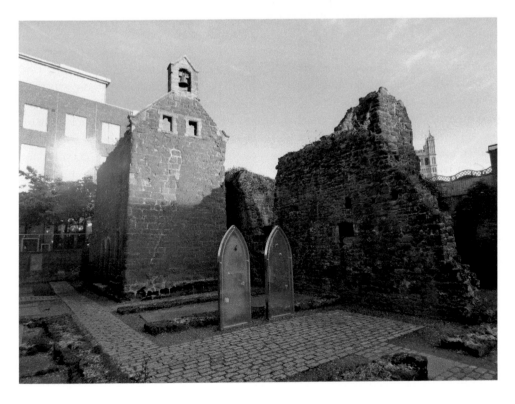

DID YOU KNOW?
If you are wondering about what the 'hay' part of the Princesshay name means, it was chosen because it fitted with the nearby, and considerably more ancient, Southernhay and Northernhay. With those older areas it refers to the fact that 'hays' were once enclosed pieces of land, but with Princesshay it was just chosen because it seemed fittingly Exonian.

Tucked away on the part of Princesshay behind St Stephen's Church are the ruins of St Catherine's Almhouses. The almshouses were founded in the mid-fifteenth century to house thirteen poor men, although it changed over the years to allow couples, as well as widows and single women, to be helped there. The site continued as an almshouse for the poor until 1893, and even after that it operated as a hostel for some time. It was bombed during the Second World War and left as a memorial to the damage wrought on the city. The glass pillars within the ruins are an artwork called *Marking Time*, which show where doorways in the complex once stood. The objects within the pillars reflect things discovered on the site, with the oldest (such as Roman) towards the bottom and the newer towards the top.

Finally, at the other end of the precinct is the current tourist entrance to Exeter's famed Underground Passages. These medieval tunnels, some of which date from the fourteenth century, are completely unique. While they have a somewhat complex history, they were all built as part of Exeter's attempts to bring clean water into the city in a way that was easier to maintain than buried pipes. They continued to be used for that purpose well into the Victorian period, and some utilities still run through them today.

All of this history is easy to find in what is one of the newest and most modern parts of the city. Indeed, Exeter is so full of hints and reminders of its past that this book has only had time to touch on a few of them (we haven't even mentioned the ancient buildings on Cathedral Close, which could have filled a book like this on their own!). It just goes to show though that in a city like this, memories of the secrets of the past 2,000 years are everywhere you look.